MARKERS
Wet&Wild

MARKERS
Wet & Wild

Watson-Guptill Publications

New York

First published in 1993 in the United States by Watson-Guptill Publications,
a division of BPI Communications, Inc.,
1515 Broadway, New York, N.Y. 10036.

Library of Congress Cataloging-in-Publication Data
Hayden, Charles.
 Markers wet & wild / Charles Hayden.
 p. cm.
 Includes index.
 ISBN 0-8230-0277-2 : $24.95
 1. Felt marker drawing—Technique. I. Title. II. Title: Markers wet & wild.
 NC878.6H38 1993
 741.2'6—dc20 93-24652
 CIP

Distributed in Europe, the Far East, Southeast and Central Asia, and South America by
RotoVision S.A., 9 Route Suisse, CH-1295 Mies, Switzerland.

Distributed in the United Kingdom by Phaidon Press Ltd., 140 Kensington Church Street,
London W8 4BN, England.

Manufactured in Hong Kong

First printing, 1993

1 2 3 4 5 6 7 8 9 0 / 97 96 95 94 93

Senior Editor: Candace Winstanley Raney
Designer: Jay Anning
Graphic Production: Ellen Greene
Text set in ITC Kabel Book

To Toni, who made this book possible

Several people need to be credited with helping to create this book: Doug Liss for encouraging me to teach marker technique, Candace Raney at Watson-Guptill for having confidence in the book's form and style, Janet Frick and Virginia Croft for shaping it into an accurate and clear presentation, and Jay Anning for giving it a cohesive design.

Many giants among my peers helped me form a method and approach to working in markers, among them Dick Naugler, Paul Wilson, John Centani, Harry Borgman, and Rudi Battenfeld.

Melissa Hayden Guerra was my dauntless assistant and supporter in this effort.

CONTENTS

FOREWORD
Markers—
A Medium for the Twenty-first Century

Markers are a modern medium: smart, concise, and highly practical. This book reflects the uniqueness of a craft that has found its special niche in our high-tech world where speed, function, and "look" are paramount.

Computers are now taking the forefront position in the world of image making, leading us right into the next century. This does not mean that other methods are obsolete, however. A knowledge of marker techniques multiplies your options for creating images that can then be scanned into the computer. This book is a prerequisite for versatile computer imaging.

This is a book for people who can draw, but more importantly, a must for people who can't draw. This seemingly contradictory statement is where the secret of this book lies.

If you are already competent at drawing, this book will show you very quickly how to incorporate a spectrum of contemporary applications, resulting in a vast repertoire of techniques. This affords you the ability to solve almost any design problem, whether in graphic, interior, advertising, product, industrial, textile, or architectural design.

If you are a beginning drawing student, this book functions on a completely different level. The exercises here are wonderful practice that will develop your ability to observe and capture on paper everything around you: people, cars, landscapes, anything you see. The comprehensive callout system, which Hayden has used to point out exactly how and where he achieved specific results, saves time and targets many subtle effects with accuracy. His artwork acts as both a guide and a standard while helping to establish an appreciation of excellence in marker techniques.

Until now, I strongly felt that marker techniques could be taught only in a classroom situation. Thanks to Charles Hayden, that is no longer the case.

RICHARD WILDE, Chairperson
Graphic Design & Advertising Departments
School of Visual Arts, New York City

INTRODUCTION

Markers are easy to learn and simple to use. There is nothing to prepare, mix, or clean up. They work fast and dry fast. Once mastered, they can be pushed (forced), overlaid, mixed with other mediums, and used to achieve a great variety of effects. These are among the many reasons why they have become so popular with artists who prepare comps for the advertising industry.

Markers were intended to be used broadly, directly, and swiftly—so loosen up and have a good time.

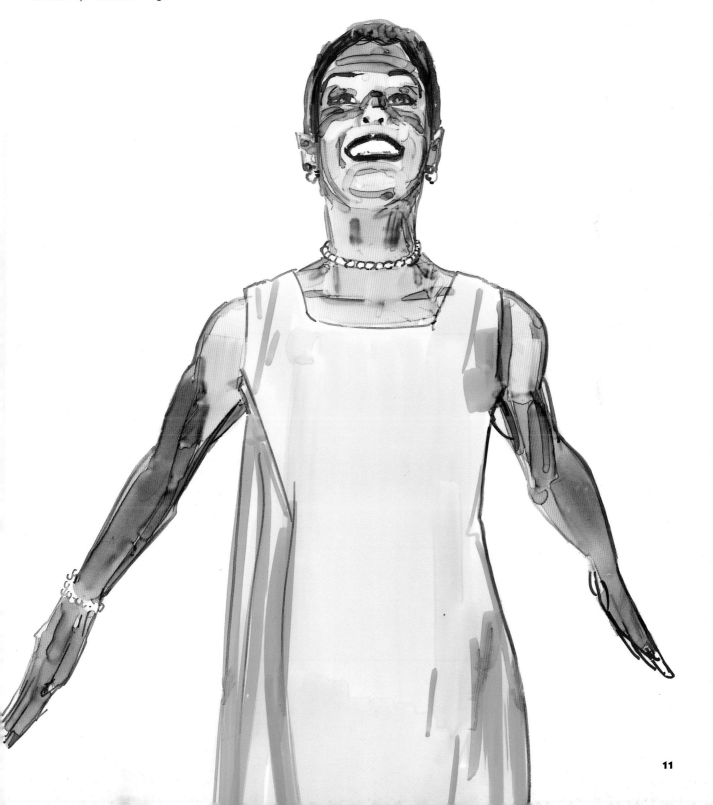

HOW TO USE THIS BOOK

This is a bite-size text. It was written to be read quickly and easily, with precise and specific information readily accessible next to each relevant demonstration.

Read, and look—but don't stop there. The artwork here is meant to be copied by hand. There is no faster way to discover the opportunities markers offer, and the tricks of the comp artist's trade, than to imitate the demonstrations. I prefer that you trace the drawings directly from the book, and then remove your drawing and refine it, using the printed illustration for visual reference. You can also "eyeball" it—copy it by eye—and work larger if you like. The important thing is to learn by doing and to work the way you're the most comfortable.

You may even choose to work on tracing paper, which is an excellent surface. Back it up later with a light bond paper, since tracing paper is rather gray by itself.

To further guarantee that you will not miss any of the fine points, I have used callouts extensively throughout the book—phrases keyed to specific points on an illustration. They serve to spotlight which colors are used where, how to achieve important special effects, and so on. Pay close attention to the callouts as you copy the artwork or do your own compositions. See if you can achieve similar effects in your own work.

I like AD Markers by Chartpak because of their recently improved, three-sided nib, which lends itself to my style perfectly. Although many other products are described and demonstrated here, Chartpak is referred to throughout for simplicity in identifying colors. In my work, however, I do use different brands, principally for color variation.

Remember, simply to copy a photograph or style, or "render tightly," is not enough. It is your responsibility as an illustrator to devise a way to make any subject appear *desirable*. That is why this book concentrates on the "sizzle" as well as the "steak." Work on portraying your subjects with dazzle!

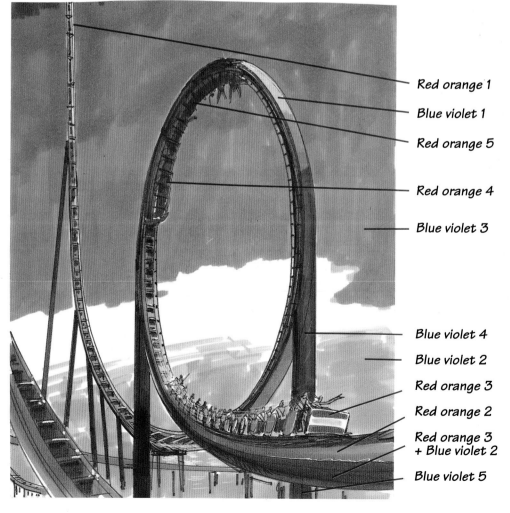

This illustration was done using only two colors of the Design 2 Art Marker Color System: five numbered values of red orange and five numbered values of blue violet.

Red orange 1

Blue violet 1

Red orange 5

Red orange 4

Blue violet 3

Blue violet 4

Blue violet 2

Red orange 3

Red orange 2

Red orange 3 + Blue violet 2

Blue violet 5

WHAT YOU NEED TO START

Actually, you need very little equipment to begin doing great work:

☑ A basic set of 25 markers.

☑ A marker pad, preferably 14" x 17" (roughly 36 x 43 cm).

☑ Pens, both fine and bold, such as Marvy Le Pen or Pilot Silvertip and a black Pentel Sign Pen.

☑ A straightedge triangle and T-square (for all horizontal and vertical lines).

☑ A soft pencil, 2B or softer.

You probably have a collection of your own markers, colored pencils, and other valuable studio tools. You will be able to use them all later, if not now. It is always better to have more than you need; otherwise your technique will be limited by the amount of equipment you have.

This is particularly true for your color palette. Always lay out all your colors and tools for any job. You will then have the latitude to push your color sense beyond what you might have anticipated.

When you can afford it, you should consider these additional supplies:

☑ A full set of 100 markers. Eventually you will use every marker, and, most importantly, you will always be working with a full palette. A full set of basic grays, cool grays, and warm grays is also important.

☑ Berol Boldmaster F-30, which has a softer point than Pentel and is less black. Buy half a dozen or a box.

☑ Berol Thinliner, which makes a good fine line.

☑ Design Art Marker 229LF, for extra-heavy black lines or textured lines, as desired. These markers are particularly good for black-and-white work.

☑ White charcoal pencil for accents or covering.

☑ Kuretake Colored Calligraphy Pens, for chiseled-in lettering or drawing crisp, clean-ended lines.

☑ Different marker papers. Use whatever turns you on at the moment. Later you will be able to handle papers with different porosities for exciting new effects.

☑ X-Acto knife and blades.

☑ No. 2 brush and bleed-proof white ink.

☑ Kneaded eraser.

☑ Colored pencil set, preferably a set of 120 Prismacolors.

☑ Large and small oval templates: small and large sets, 10 to 80 degrees, plus circle template.

☑ A "clothespin" (clip) compass, which works well for holding a full-size AD Marker. A conventional compass with a universal compass adapter to hold a Pentel Sign Pen is also useful.

☑ Ship's curve for drawing gently curved lines.

☑ Exhaust fan, air purifier, and/or small table fan.

Some markers contain alcohol as a solvent; others are water-based and considered safe for children. Still others are advertised as "environmentally friendly" or "virtually odor free." Many markers now carry the AP nontoxic seal. The marker industry is working to make its ingredients safe under all conditions—but adequate ventilation and common sense are still advisable. The best protection is an open window and exhaust fan, with the resulting draft pulling the marker odor away from you as you work. A small table fan to remove fumes quickly and an air purifier are also good ideas.

Markers in the short run are lightfast unless they are subjected to continuous sunlight. However, if you wish to keep marker art over a period of years in its original bright state of color, protect it from all light, preferably in a black folder and stored in a light-free drawer.

Marker Brands

There are many good brands available. Here are some of the principal brands, all good and with a fairly wide assortment of useful colors:

Chartpak AD Markers have a three-sided nib—small, medium, and large, with the widest side being 5/16" (8 mm), wider than normal so that you can cover large areas quickly. This type of nib is extremely useful because you can instantly turn the marker in your hand as you work, for great versatility. The nib is also made of a material that allows the marker fluid to go down with wonderful smoothness. I used Chartpak markers for the illustrations in this book because I believe them to be the most practical, and I have used them as the standard in my marker classes with much success.

With any marker brand, it is important to use the largest nib unless you are doing very fine work. Most small work can be handled by manipulating the larger nib or "creeping up" on the line. Using a small nib for large areas is restricting and linear in character.

Pantone markers have excellent colors keyed to Pantone's color matching system, which includes papers, printing inks, and overlays. All the colors are indexed in a numbered color selector book. However, numbered markers slow you down a bit because it takes longer to identify a color by a number than by a name. Also, the angled cap is awkward to replace quickly.

Marvy Water-Based markers are high in quality, but they come in only 60 colors. Also, the nib is smaller than standard. I use a set of 60 Marvy Fine Points, which come packed in a flat tin tray in plastic cradles. These are much finer than the fine-point faucet of Chartpak AD Markers.

Design Art Markers are a good product, offering 96 colors with a range of broad, fine, and extra-fine nibs. I don't recommend buying the finer nibs unless you can afford this set along with a broad nib.

Design 2 Art Marker Color System by FaberCastell is a well-thought-out method for organizing colors chromatically, which is particularly useful for beginners. There's no need to search for a matching shadow color because there is a range of five values from which to choose. Each of 16 colors has four additional hues running from light to dark. So it is failsafe, but at the same time constricting, since you are limited to relatively monochromatic tones within any color range.

Zig Clean Color markers come in a set of 36 or 48 double-tipped fine-point markers: 0.5 mm and 1.2 mm.

They hold their points well and come packaged in a neat, simple folding wallet with individual sleeves.

Copic is a new, twin-tipped brand of superb quality, carried only by Sam Flax in New York. The markers come smartly packaged in their own caddy. There are 214 colors with refill dispensers available. In addition, a range of nine replacement marker nibs is available for

A sampler of marker brands. Experiment with different kinds to discover those that you like best.

use with the markers. Of particular value are the wide nibs, called coaters, which are 2 inches and 4 inches (5 cm and 10 cm) wide. These coaters can be fed ink of any color, so that you can do excellent flat washes.

Berol Prismacolor is a double-pointed pen with a fine and a broad nib. It's a good system, but the markers tend to stick in the caddy, which must be stabilized to keep from tipping. For me, a well organized storage system is important.

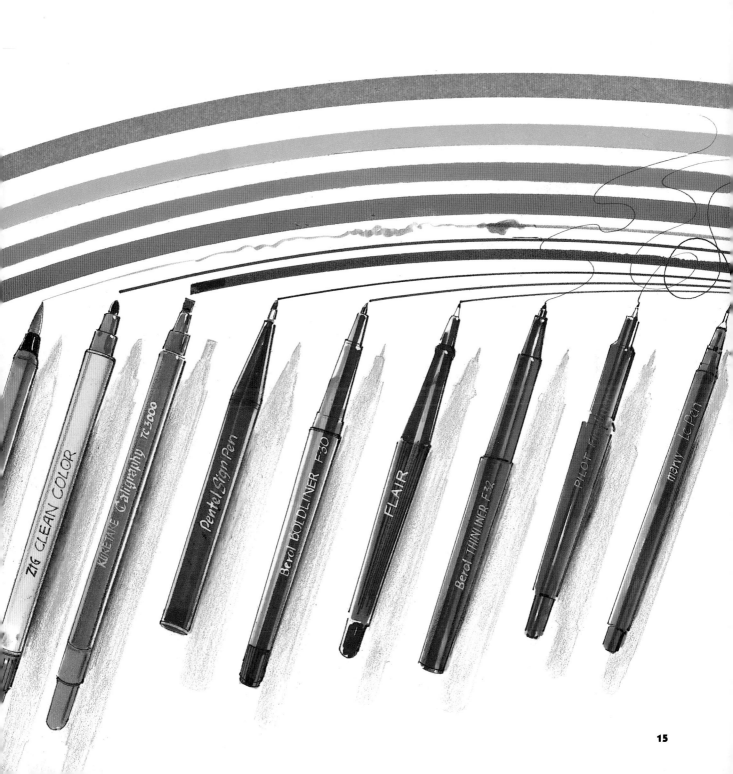

A BASIC MARKER SET

Start your marker palette with the minimum if you must. As soon as possible, you should add as many colors as you can afford. It will make learning easier, more enjoyable, and faster. Here is my student palette, paired by lighter and darker colors for their shadow value. In the center is an even darker value achieved by going back over the darker value. The same effect can by produced by going over the lighter value, but the result is usually too subtle to be useful.

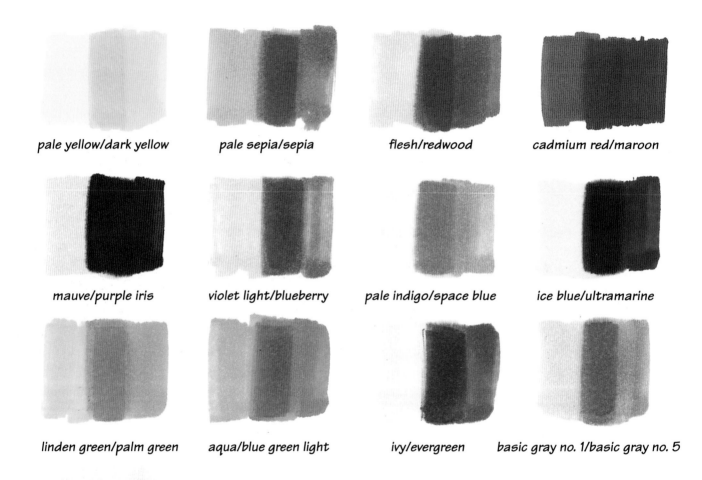

pale yellow/dark yellow *pale sepia/sepia* *flesh/redwood* *cadmium red/maroon*

mauve/purple iris *violet light/blueberry* *pale indigo/space blue* *ice blue/ultramarine*

linden green/palm green *aqua/blue green light* *ivy/evergreen* *basic gray no. 1/basic gray no. 5*

warm gray no. 1

Basic palette paired for compatibility. All colors shown are Chartpak AD Markers.

Demonstration:
Working with a Basic Marker Set

The painting below was done with the basic colors shown on page 16.
You must work with at least 25 colors to do a respectable job of portraying
most subjects. This is partly because unlike paints, markers cannot be easily
mixed. What you have in your palette represents your total range of colors.
Still, working with a basic palette can be good discipline.

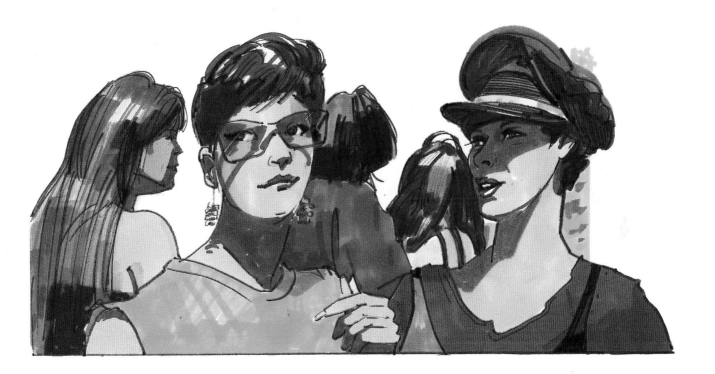

EXERCISE:

Using a limited set of 25 markers as described on page
16, copy this painting. Trace the drawing on tracing or
other marker paper, and then use the printed illustration
as a reference guide. Notice that with 25 colors you are
somewhat restricted, but that's often a good way to start.

AN EXPANDED PALETTE

As soon as you're able, add the expanded palette to your basic set. That will give you a set of 50 markers (24 colors with contrasting darker colors, plus warm gray no. 1 and black.) My palette is 100 colors, four caddies. It includes colors from Chartpak, Pantone, Design 2 Art Markers, and Copic. I often drop colors and add more exotic ones to pull me into more exciting combinations.

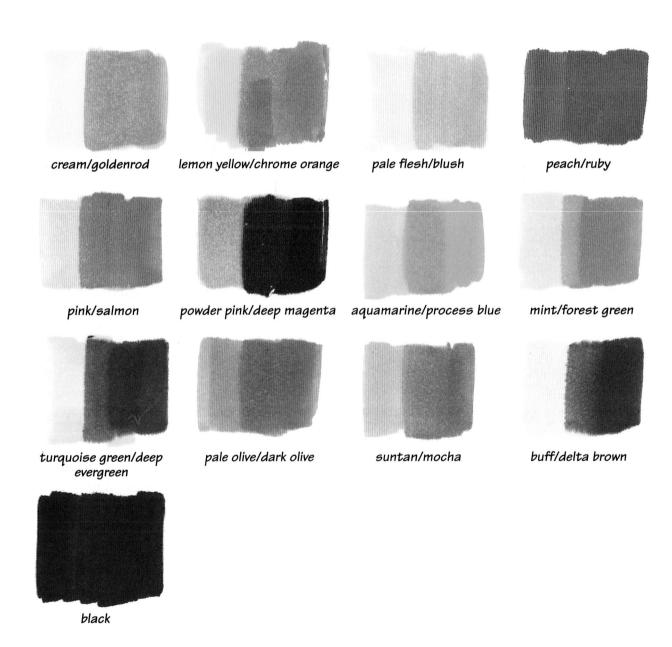

cream/goldenrod *lemon yellow/chrome orange* *pale flesh/blush* *peach/ruby*

pink/salmon *powder pink/deep magenta* *aquamarine/process blue* *mint/forest green*

turquoise green/deep evergreen *pale olive/dark olive* *suntan/mocha* *buff/delta brown*

black

Expanded palette, with colors again paired for compatibility.

Comparing a Basic Palette with an Expanded Palette

The combinations below will exactly double your capacity to produce a fine picture. The sooner you do this, the more quickly your marker adventure will progress, and the greater your enjoyment will be. This will fill a second caddy, which will still be very portable if you work or paint away from your studio.

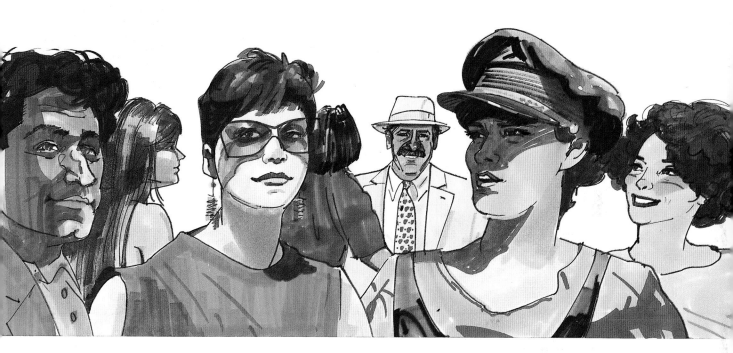

EXERCISE:

Now copy this painting and see how an expanded palette facilitates your color selection. A larger choice of markers also enables you to work faster because it's easier to locate an acceptable color.

PAPERS

Second only to the markers themselves, the paper you use is the most important physical element of your artwork. Papers run the gamut from the coated, nonabsorbent kinds to extra-porous varieties. They result in quite different effects and should be chosen with that in mind.

It's important, for beginners especially, to use a paper that's familiar and easy to work on. Beyond that, the choice is up to you. While the more absorbent papers result in rich dark colors, they also tend to bleed, and edge control can be difficult.

On the other hand, coated or nonporous papers tend to let ink float on the surface momentarily, permitting you to push the color around or even scrub out. Use a blender or light marker for this purpose.

In addition to the papers shown on the opposite page, there are many other interesting papers that can be used with markers: Bienfang 340 or 307, inexpensive bond, newsprint, and tracing paper, to name a few. Depending on where you live, you can always find an acceptable marker paper, and often your local art supply store can order paper for you if it's not already in stock.

Illustration on Denril multimedia vellum. Notice how the color swims on the surface. Color can be lifted or pushed out, leaving a dark edge much like watercolor.

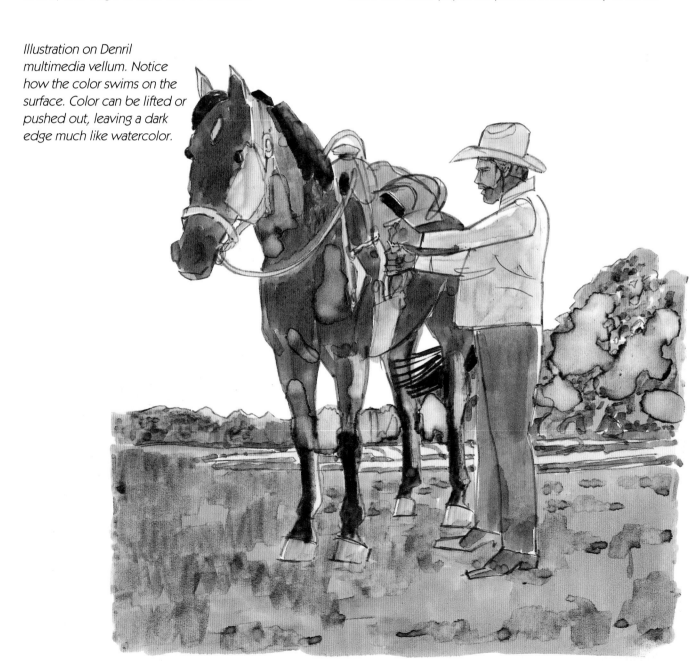

Varying Paper Characteristics

Look at the difference in the personality of these wildly divergent papers.

Bienfang 360 is characterized by lighter color in general. It is easy to rework and modify, and is a fine choice of paper where many pastel shades are required. Allow an instant for pen lines to dry before touching them, or they will smear.

Bienfang 360 (back side), unlike many papers (such as Plaza 90D) is highly workable even on the unfinished side. Colors will appear darker when applied to the back surface than when applied to the front.

Plaza 90D has very rich color and softer edges. This paper is very useful for general subjects, especially skin tones, where a lot of punch is desired.

Vellum is characterized by a loose, painterly look. Areas can be pushed around, erased, or scrubbed out by using a solvent and a cotton swab. Knock out darker colors with a pale color or blender. Vellum is great for showing speed or textures.

Rice Paper and other more porous papers soak up a lot of color and show it. Color is always dark, and edges bleed as much as 1/16" (1.6 mm). These papers are excellent for flowers, water, and landscapes.

Charcoal Paper

Intended for use with charcoal, this is a textured paper with a tone. It comes in many colors, but the important feature is that it is already printed with a light value, so only darker and lighter values need to be added. This permits a totally different look from anything you can achieve on white paper. Charcoal paper is particularly useful for large illustrations.

Tempera white

Black colored pencil

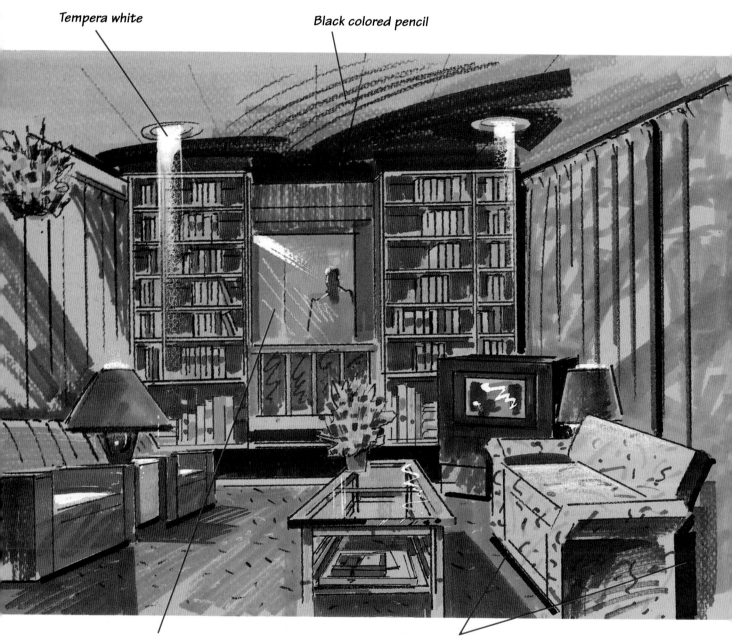

Prismacolor white

Black markers, which must be rich and dark

Wrapping Paper

This is ordinary kraft wrapping paper. When you are working on a large
illustration requiring a lot of color, consider this inexpensive alternative.
You already have a large area of tone printed on the paper. It also facilitates
a very different look—splashy, romantic, with lots of flair and verve.

Opaque white, applied with quick dabs

*Black Prismacolor pencil, put
down with splash and pizzazz*

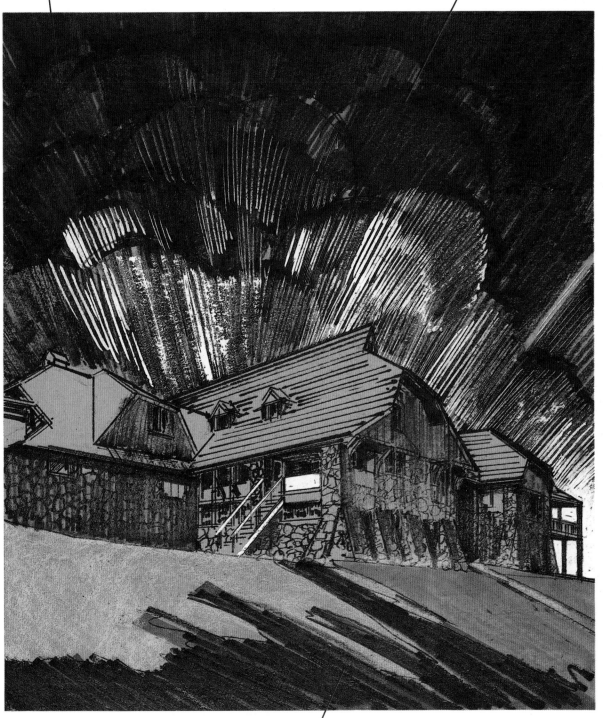

Design Art Marker 229LF

Vellum: A Giant Leap in Marker Effect

By working on vellum, you can achieve all kinds of special effects because markers react in a totally different way. Denril multimedia vellum is an exciting surface when used with markers, solvent, pencil, your finger, cotton swabs, and paint. You can't get wild enough. On vellum you can remove marker, which is impossible on most marker papers. Notice the different effects, achieved principally with solvent.

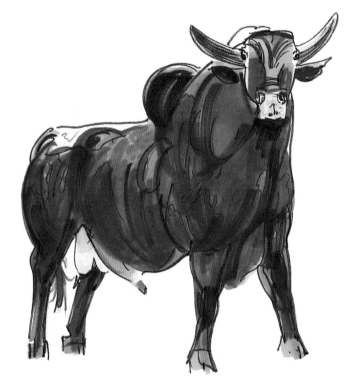

The illustration on the right was done on Plaza 90D paper, a porous surface. Notice the difference between it and the illustration on vellum, below!

Plaza 90D paper has the effect of spreading the marker ink, darkening the color and softening edges. Once the ink is down, it sinks immediately into the paper and spreads. On vellum, marker ink is totally fluid. It simply lies on the surface and can be moved, allowed to run, erased, or spotted with thinner to make a hard "watercolor" blossom.

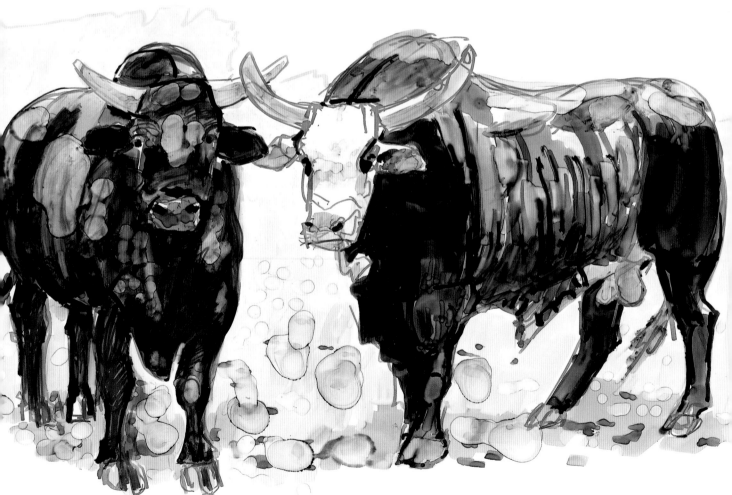

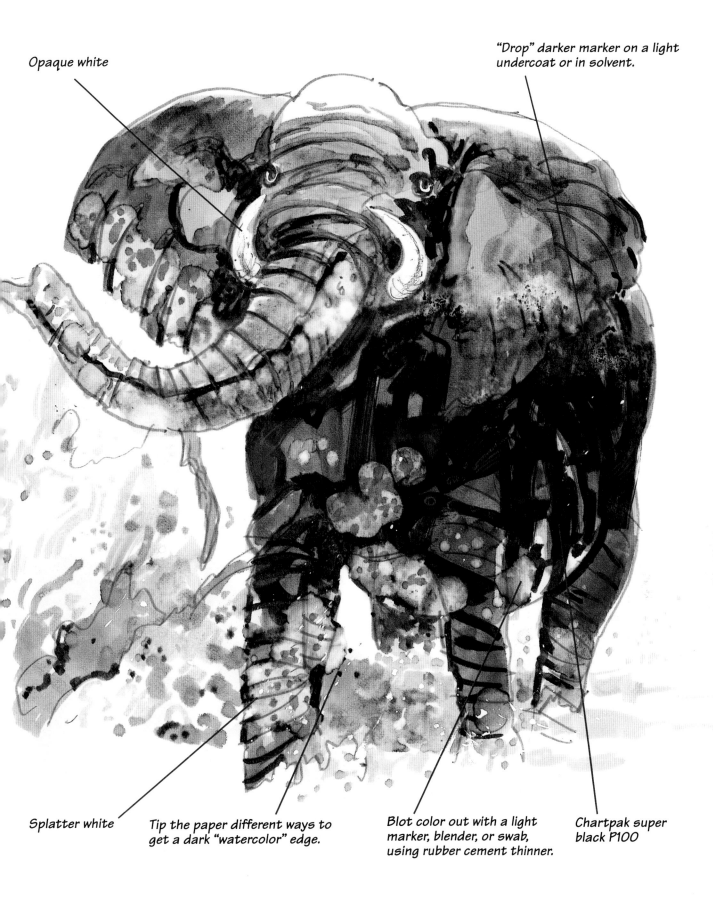

Opaque white

"Drop" darker marker on a light undercoat or in solvent.

Splatter white

Tip the paper different ways to get a dark "watercolor" edge.

Blot color out with a light marker, blender, or swab, using rubber cement thinner.

Chartpak super black P100

THE WET LOOK

Working wet is the basis of any marker work you will do—even if you are painting a scene as dry as this desert. On that first wet application all else will build: grading, bleeding, glazing, blending, and dry marker. All marker techniques begin with an underpainting of a fully charged marker.

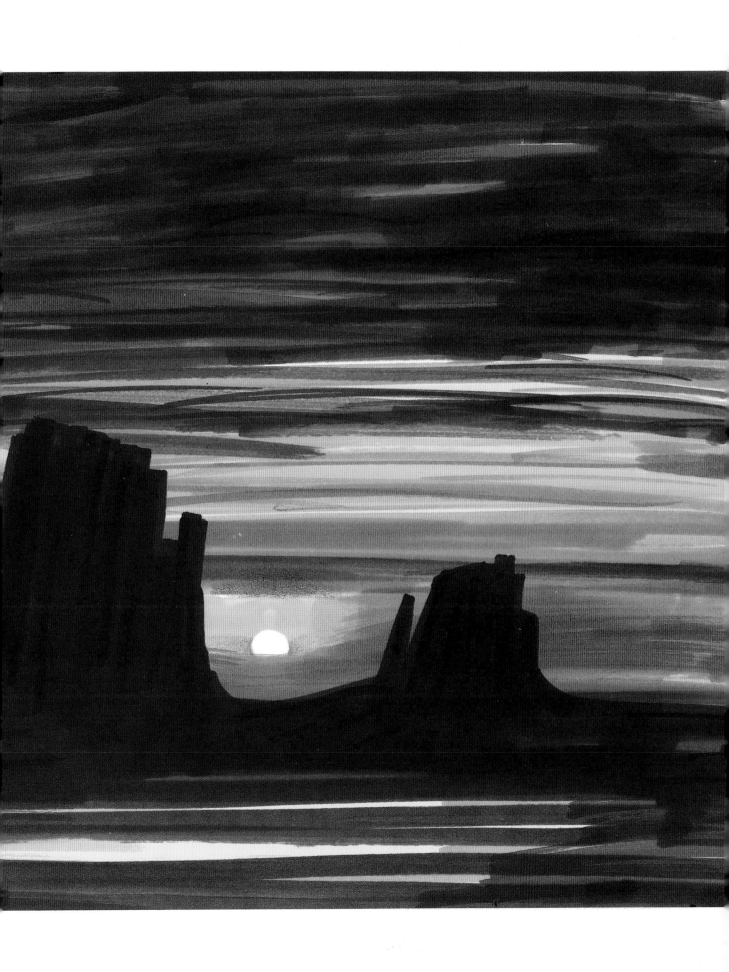

Go Ahead—Get Wet!

It's important that you know the difference between wet and dry markers and use them to complement each other. A marker that has dried through use or age can't lay down a fully saturated wash and will leave only a streaked, weak stroke with paper showing through.

Be bold! Use a sweeping arm movement instead of wrist motion. I like to think I'm painting in watercolor, holding the "brush" loosely and letting areas bleed into each other and cause interesting little "accidents." Actually, they are never accidents, because we wish for and encourage them.

Use a low-porosity paper like Bienfang 360. Begin by selecting three fully loaded markers—one light, one medium, and one dark. Uncap all three, since you must work swiftly. You won't have time to remove and replace caps.

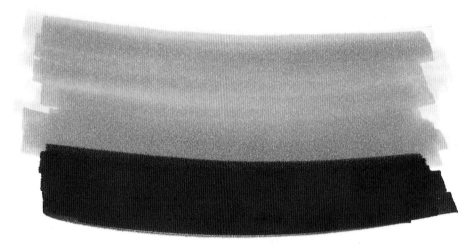

Quickly lay down a wash of the lightest color, covering a small area. Use the broad side of the nib. Follow immediately with the medium marker, overlapping. Evaluate the effect. If it seems a bit dry, repeat the process immediately.

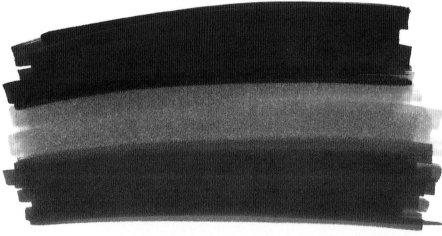

Continue with the third marker, overlapping the second and scrubbing to feather the edge.

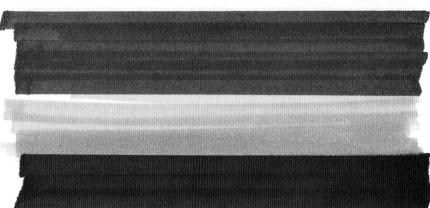

Notice the difference when the marker is applied dry! Practice until you can achieve a perfect blending every time.

Opposite: I did this illustration on Bienfang 360 paper, blending six marker colors in the sky alone.

Trees blended with the sky give
the effect of light fog or mist.

Sky blue

Blending space blue with sky blue
gives the effect of distant rain.

Pink is
blended into
the sky to
suggest
approaching
dusk.

Ice blue

Warm gray
no. 1

Pale indigo

Pink

Space blue

Mountains and trees are saturated
to darken and simplify, giving more
attention to the splashing wave.

Demonstration: Loosen Up

When doing panoramic landscapes or seascapes with the wet look, you have the opportunity to wing it a little and apply the marker fluid liberally and loosely. Remember to use a sweeping arm movement, not wrist or elbow action.

First do a rough pencil outline indicating the major components with a 2B pencil. Later you'll eliminate this with a kneaded eraser, leaving only the marker.

Mark the darker areas in the sky with diagonal lines to differentiate them from the areas that will stay light. This trick will prevent you from getting confused as you paint the colors in. Lay in the darks early on. This guarantees that you will always have an illustration with plenty of power. Working up from pastel tones can make you apprehensive about ruining a successful start by going too far.

Outline major areas lightly with a soft pencil, giving consideration to designing the shapes of the various elements.

After laying in the major flat tones, immediately begin laying in the darkest areas. Here I laid in the lemon yellow and ice blue and then worked on the rock formations with delta brown. Again, shapes and good draftsmanship are important, even in the simplest composition.

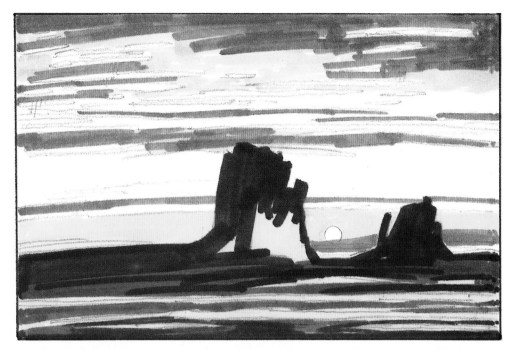

Continue laying in the darks, leaving the middle tones until later. The dark streaks in the sky are Chartpak's blueberry color.

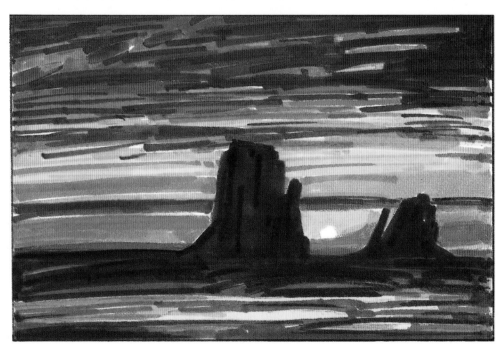

Add middle tones last, sweeping right through the dark areas in your path. The strokes must be continuous and horizontal in direction, following the cloud paths.

With some marker brands—especially if you are moving across black on a hard-surfaced paper—the lighter color may pick up some of the darker one you have crossed. However, this will only create a softened edge and can be used to your advantage. You may wish to test the colors first on a small sample of the paper.

The finished illustration contains quite a few additional colors, all pulled into a harmonious whole with the wet technique: dark yellow, cobalt blue, ultramarine, mauve, bright orchid, violet, cadmium orange, chrome orange, cadmium red, pale sepia, burnt sienna, and burnt umber. Finish by adding black accents in the dark areas.

Painting Skin with Wet Markers

Skin is by nature round and soft with few sharp edges. Try not to meticulously "copy" the figure. Work with imagination, daring, and speed. Your illustrations should not look labored and tedious.

Skin is alive and vibrant, and so are we. Pick three or four fully loaded colors and make them wail!

Begin by laying in an underpainting of Chartpak's flesh color. You may plan a highlight, but otherwise cover everything. If you're concerned about the color bleeding through to the next sheet of paper, use a sheet of acetate to block it. You can wipe it clean and use it forever. Don't be afraid of using generous amounts of the fluid—get your money's worth!

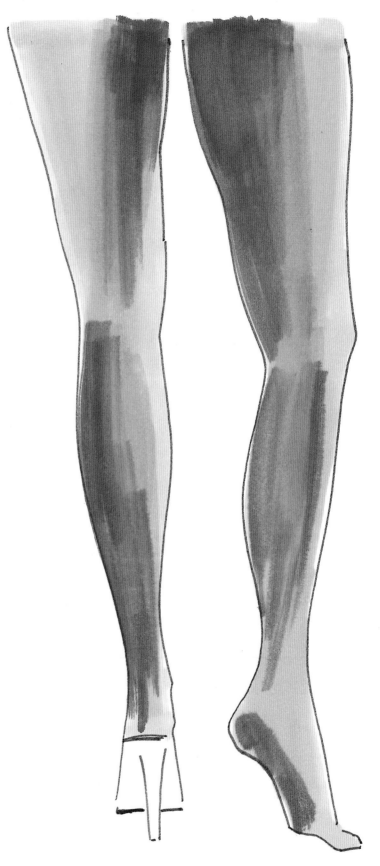

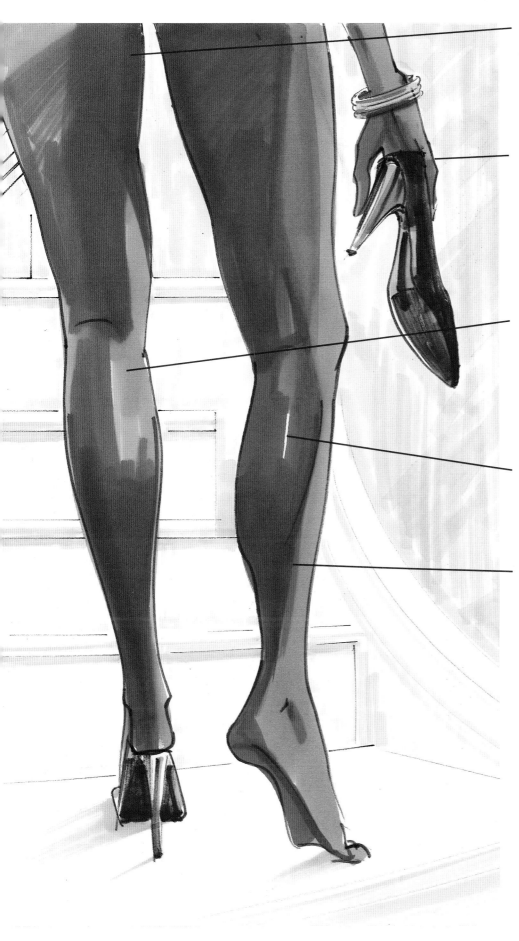

As soon as possible, add the darkest value wet—redwood in this case—and use the flesh color again if necessary to blend and soften.

Add the hand holding the shoe for interest. Why not? It can always be taken out if you change your mind later.

Add desert tan to bridge the first two colors.

A spot of white to suggest a "hot" spot, or highlight.

Use a dry delta brown or other dark brown to turn the leg. Notice the blending is not perfect—some edges were left hard to contrast with the softness of other areas.

THE DRY LOOK

Any marker, if exposed to the air without putting the nib to paper, or if used profusely over a large area, will make a dry mark. It will leave a unique track with a very satisfying texture. When used in parallel strokes, it has very much the feeling of movement, as though the line itself were zooming off the page. When used to indicate clouds, it suggests swift movement across the sky. Just as the wet look can be used to paint a desert, the dry look can be used to paint a seascape!

Always *plan* to use dry marker only for the effect it produces, not because the marker has dried. Make it a point to replace dried markers quickly and use them to build a dry set.

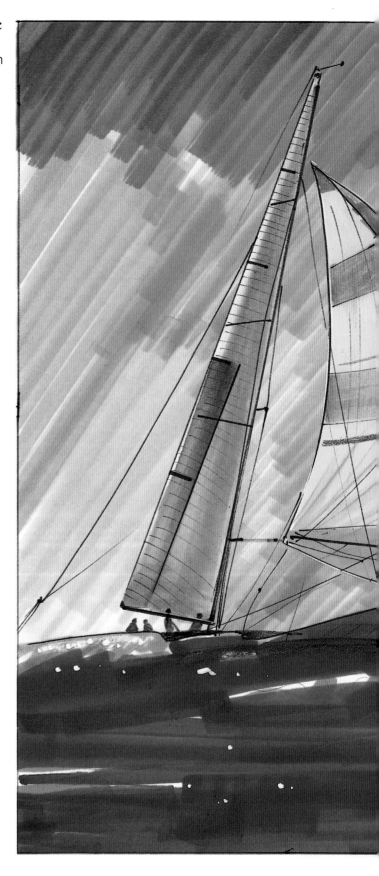

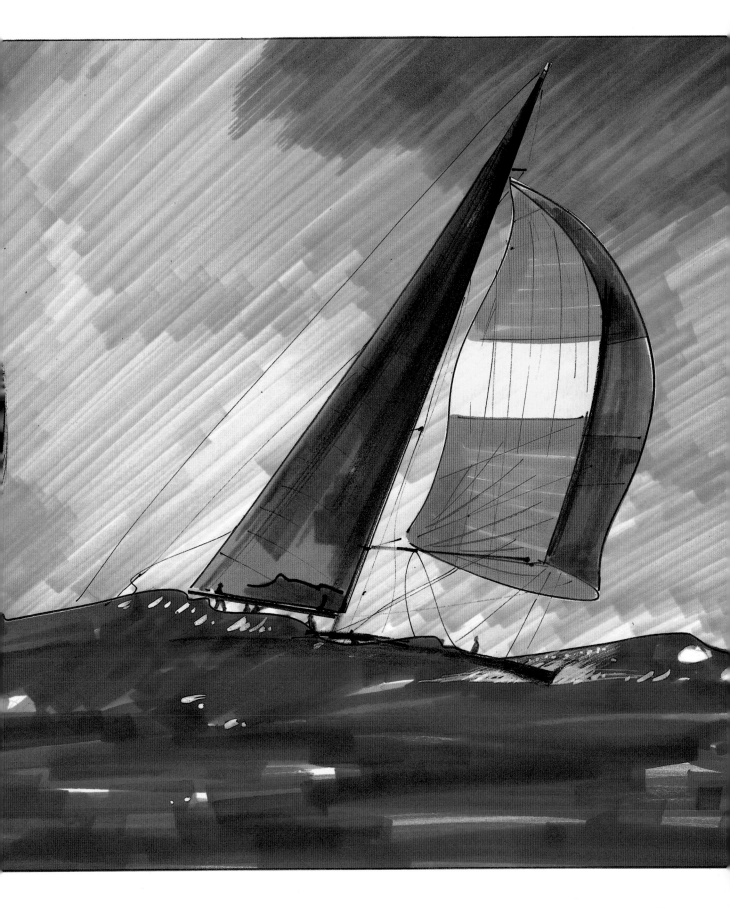

Work Dry on Purpose!

Markers can dry simply through age or being stored in a hot or dry location. Often this happens so gradually that it's barely noticed. Too many artists work with dry markers without realizing it.

Work dry deliberately—not because your markers have dried.

Start by laying down a light wash and use a dried marker against it, since this immediately gives you a contrast of surfaces. Use the broad side of the nib, and a rough-surfaced paper like Plaza 90D, or any inexpensive bond.

Try different methods of applying strokes—first with a light touch, then with some pressure. Try arcs, then a straight edge, releasing pressure on the marker to add variety.

Adapt any techniques you can think of. Try splitting an old nib with a blade to get parallel lines.

Lay down a flat wash. Scrub liberally with a dry marker so that the "dry" fluid lies on the wetter surface. While the wash is still wet, experiment with a wet marker to get an even different result.

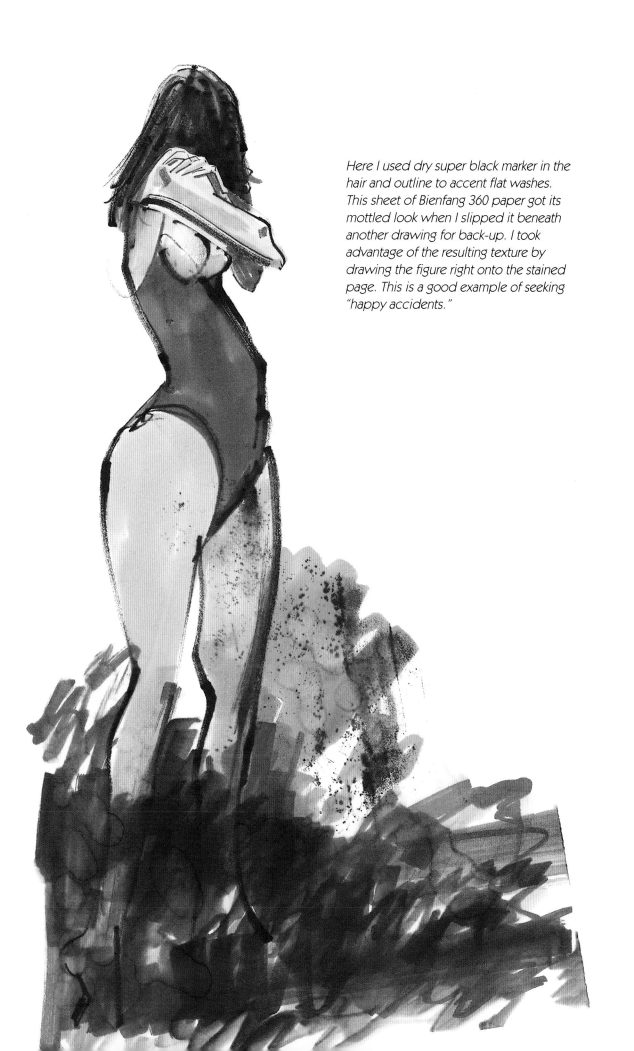

Here I used dry super black marker in the hair and outline to accent flat washes. This sheet of Bienfang 360 paper got its mottled look when I slipped it beneath another drawing for back-up. I took advantage of the resulting texture by drawing the figure right onto the stained page. This is a good example of seeking "happy accidents."

Demonstration: The Dry Look

I used the following Chartpak markers for this demonstration: Dutch blue, space blue, and mauve for the sky; ultramarine and Prussian blue for the water; and deep magenta, lemon yellow, purple sage, blueberry, warm gray no. 1, warm gray no. 3, ice blue, and aquamarine for the sails.

To leave a textured or dry edge at the end of your stroke, start the stroke outside the picture area and finish the stroke by quickly lifting the marker off the paper surface.

Begin by applying the dry marker in parallel strokes as shown. If the marker is too wet, hold it in the air for a few minutes, and it will temporarily dry enough to make a textured stroke.

Draw all the sails on a separate sheet of paper, to be attached to the background in the next step. Here also, let the strokes overlap the sides, so that they leave a clean mark. When you trim them before mounting them onto the background, they will have a perfect, clean edge.

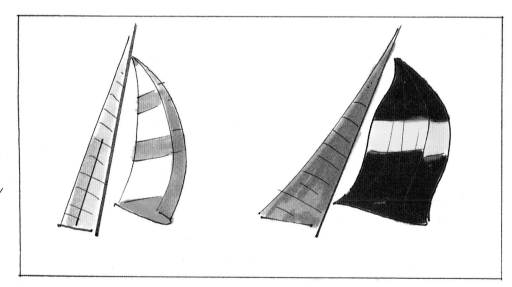

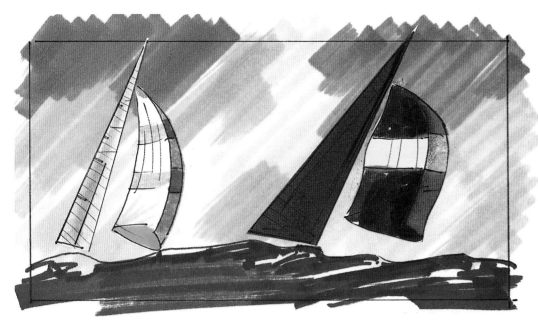

After backing up the sails with a light bond paper to make them opaque, cut them out with an X-Acto knife (and a straightedge, where appropriate) and rubber-cement the sails into place on the existing sky. Or you might prefer to do the sails on translucent paper to let more of the sky show through.

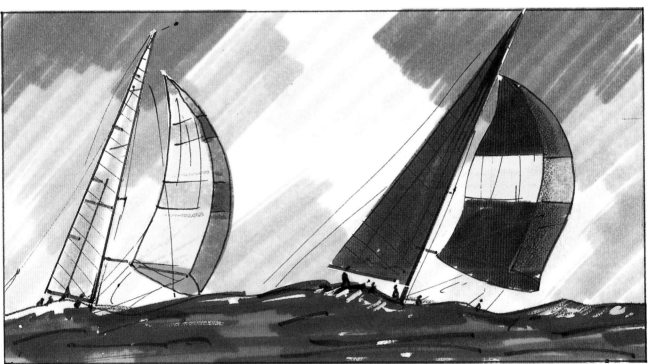

Now add detail. Do the shroud lines freehand after checking your pen on other paper. Locate the position of the line on both ends and make a generous arc. Use Dr. Martin's Non-Bleed White for highlights on the water or metal fittings. Use a jet black line for the same purpose.

Dry Marker on Porous Paper

Dry marker has a ready companion in rough, coarse, inexpensive paper. If your marker is not dry when you begin, it will be soon. Go with it. Try to keep the look rough and dry, without wet washes anywhere.

To feather the edge, lift the nib at the end of each stroke. Try not to go over your preceding strokes, because that would destroy the character of the dry strokes and make the new strokes not match the old.

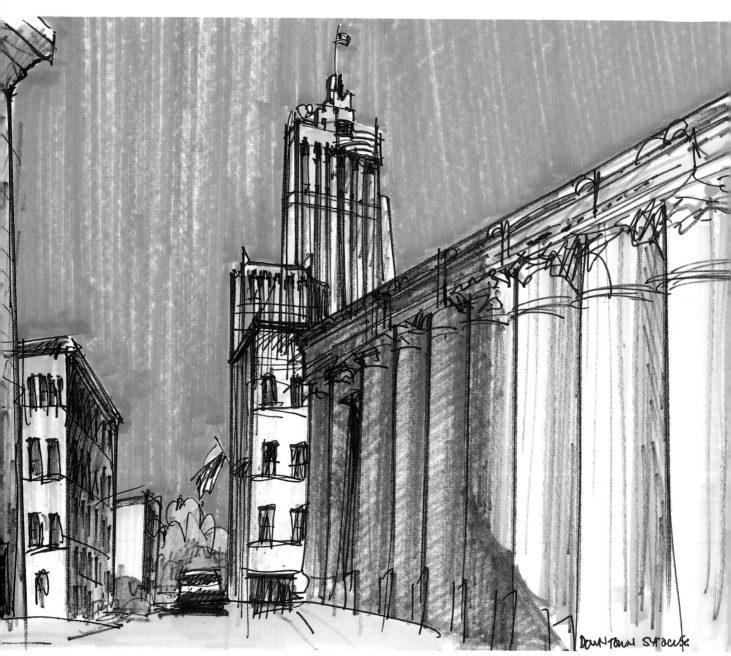

It would be easy (and tempting!) to work into this painting of downtown Syracuse with flat washes, but parallel dry strokes have a life of their own that gives the scene a special verve.

I painted this scene when I dropped off my daughter at college. The dry strokes have the same vitality and spunk as the frat members!

This was done on porous sketchbook paper, which automatically dries the marker by soaking up the fluid much like a blotter. Use swift strokes and lift the nib quickly at the end to avoid a blot.

This illustration could have had a lot more solid washes, but the whites showing between the strokes of color add a brightness it would not otherwise have, particularly in the sky. Freehand parallel diagonals add a loose, breezy quality.

FLAT WASH

A flat wash is not always the simplest effect to achieve, but it's well worth the effort. It provides a welcome relief to the eye while making more involved textural effects stand out by contrast.

If you work on a porous paper, move the marker slowly so that the paper doesn't absorb too much fluid at once. Use fully loaded markers, and stay away from large areas. Even a fresh marker will give out temporarily in the middle of a wash if used over too wide an expanse of paper.

Use parallel, overlapping strokes. If necessary, add another wash using strokes in the opposite direction.

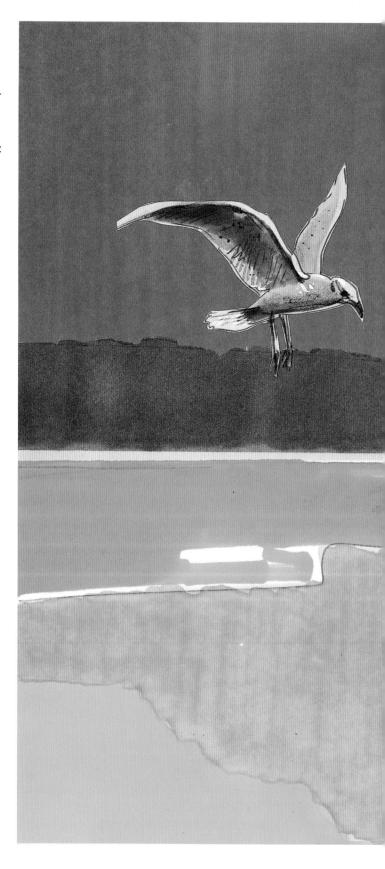

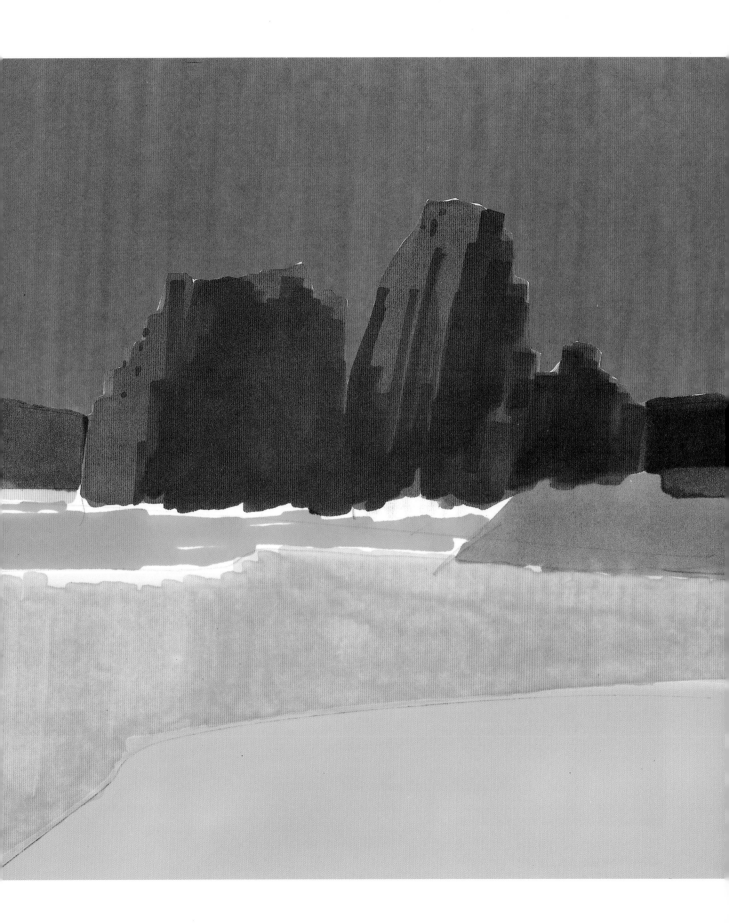

Flat Wash Effects

A flat wash is beautiful when used correctly. More often I use it as a modified wash—altering it by adding reflections, shadows, and varying color slightly from one edge to the other. But still it will have the character of a simple flat wash. The idea is to make it appear to reflect changing illumination. A perfect flat wash is a beautiful "rest" for the eye.

Notice what happens when the marker is too dry. This is a sign that it may be time to make a trip to the art supply store.

Having now secured a fully loaded marker, use horizontal strokes to fill the area.

Now make vertical strokes left to right, being sure each stroke overlaps with the last.

On Bienfang 360 paper or similar hard-finish papers, you may have difficulty covering because the fluid will not penetrate easily. Those in the left column were done on Plaza 90D; note the contrasting look.

The three examples on this side of the page show how you can darken a flat wash on Bienfang 360 paper by applying more layers.

This area is now perfectly flat, but it may be darkened by adding an additional layer.

Try scrubbing trees into the sky to move them farther into the distance. This is one instance where going over an area with repeated strokes is justified.

Leave a little light sky to establish distance even further.

Use the flat side of a dry Berol Boldmaster to give the pole a turning edge.

Color was "pushed" (deliberately exaggerated) in eaves, stack, roof, and car.

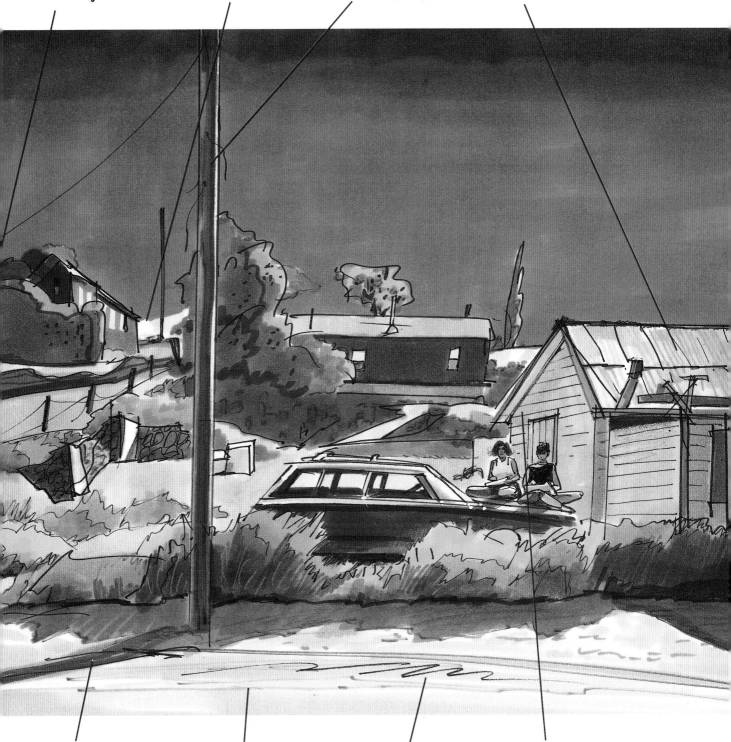

Use violet for shadow of the pole as is typical of hot, dry climates.

Use a cream or pale yellow streak to bring the foreground forward.

A hard, almost careless black Pentel line gives the illustration a "painted" feeling.

Gray of shack picks up subtle reflections as it goes from left to right.

45

Demonstration: Flat Wash

A flat wash is not always an easy technique. I often move down—darker—a value or two to smooth it out. This adds color and richness as well. In this demonstration I used Plaza 90D paper, which darkens the value of colors.

Lay down a wash of space blue using a vertical stroke over a pen outline.

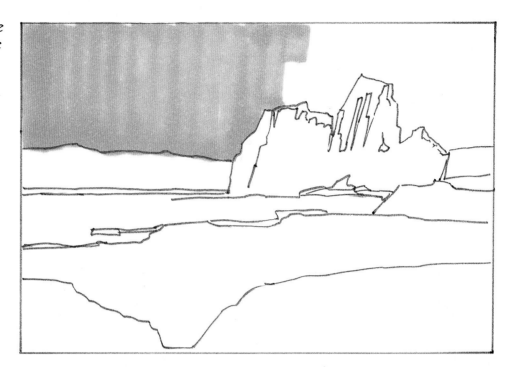

Proceed with olive, also laid in vertically. Working across the narrower dimension of a shape gives the marker an instant to recover after each stroke, whereas a longer stroke would deplete it more quickly.

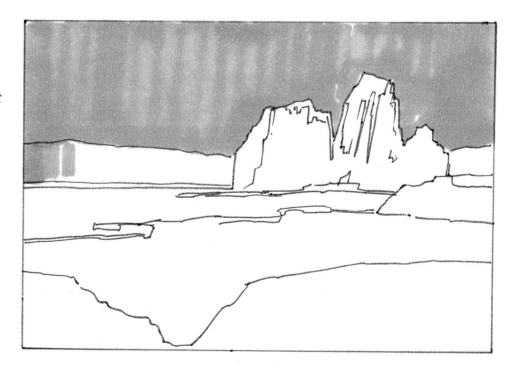

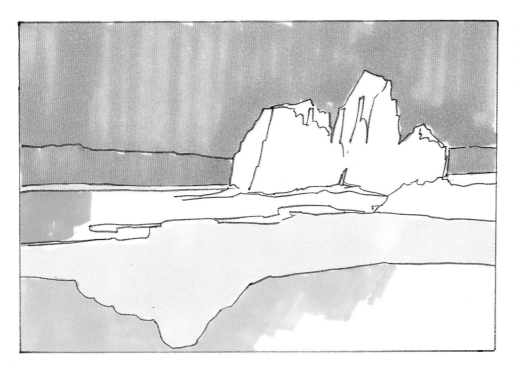

Now add process blue to the water and continue with banana, ice blue, and linden green.

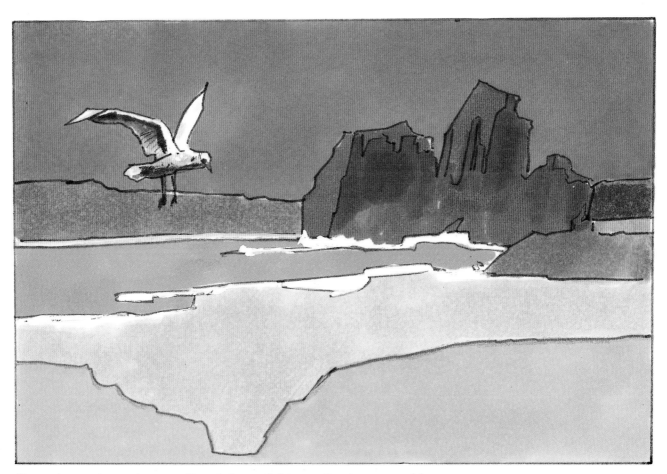

The rocks are deep salmon and burnt sienna. Paint over the sky a second time, using a wet space blue. The strip of land in front of the rocks is bright orchid over warm gray no. 2. Do the gull separately, and attach it to the background with rubber cement. In this case the sky was done separately as well, and attached beneath the remaining illustration.

GRADED WASH

The graded wash is an important and beautiful transition technique for going from dark to light.

Here is one method. It's a useful way to cover large areas or kick a little life into your painting. This technique makes deliberate use of short strokes to prevent the marker from losing its fluid midstroke when covering a large area.

A conventional graded wash looks smoother, as if painted with watercolor. The trick is to use a nonporous surface (such as Bienfang 360 or tracing paper) and new, fully loaded markers. Work swiftly with several colors of markers at a time, keeping them all uncapped and close at hand to make blending easier.

Graded Wash Effects

Grading is achieved in different ways depending on the wetness of the markers and the particular type of paper. I often switch to another type of paper if I am having difficulty getting the look I want.

To create a sky like this, lay down a cream background, and then use short vertical strokes of goldenrod, cadmium orange, and chrome orange.

Conventional grading produces a smoother look. For this effect, keep it wet. Hold ice blue, sky blue, and ultramarine uncapped in one hand. Keep the paper wet with the ice blue, and work at getting a smooth transition.

EXERCISE:

Work on vellum or tracing paper. From Prussian blue at the top, grade to the white of the blank paper with a mauve marker. Try it several times and evaluate the results. Mauve on vellum or tracing paper will be very pastel because of the paper is nonabsorbent. Consequently these papers are excellent for the purpose of grading.

Now use a blender to grade from black to white. Blenders are intended to mix colors when you are using glass as a palette. The best use I've found for them is blending graded washes or erasing unwanted colors—but again, only on vellum or tracing paper. Blenders are not efficient on porous papers.

For this illustration I used Bienfang 360 paper, working quickly and alternating between the lighter and darker value to smooth out each color transition.

First uncap pink, cream, ice blue, sky blue, ultramarine, and Prussian blue. Begin at the bottom with cream and work upward quickly, overlapping as you go. If necessary, go over the darker color with the adjacent light color to attain the soft edge. When you are satisfied, add the chrome orange band at the bottom. The mountains are violet, deep evergreen, and evergreen.

Against the gentle softness of a graded wash, try to impose the strongest contrast possible. In this case, it's the hard-edged ridges of distant mountains. The foreground is also dark, hard-edged, and undefined.

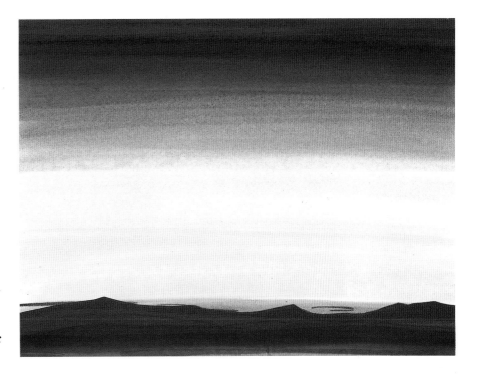

BLENDING

Blending is the mortar that binds the illustration. It provides the softness that counteracts hard edges and swift lines.

The secret of blending is wetness. Plan ahead and hold two or three open markers. While quickly overlapping, try to keep the surface wet by successive applications of the lightest color or by using a wet blender.

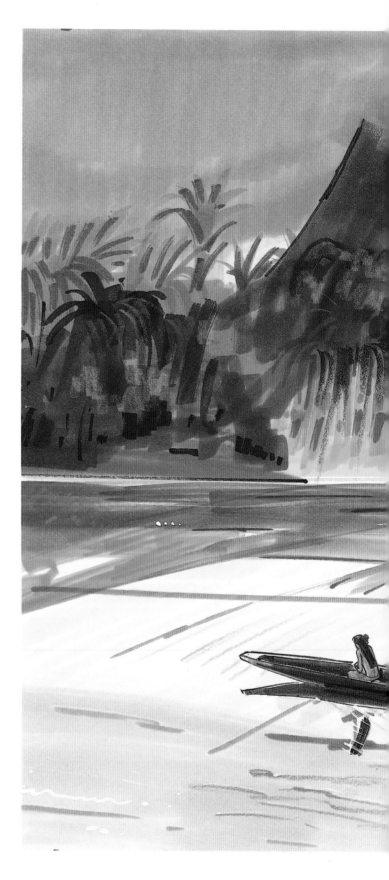

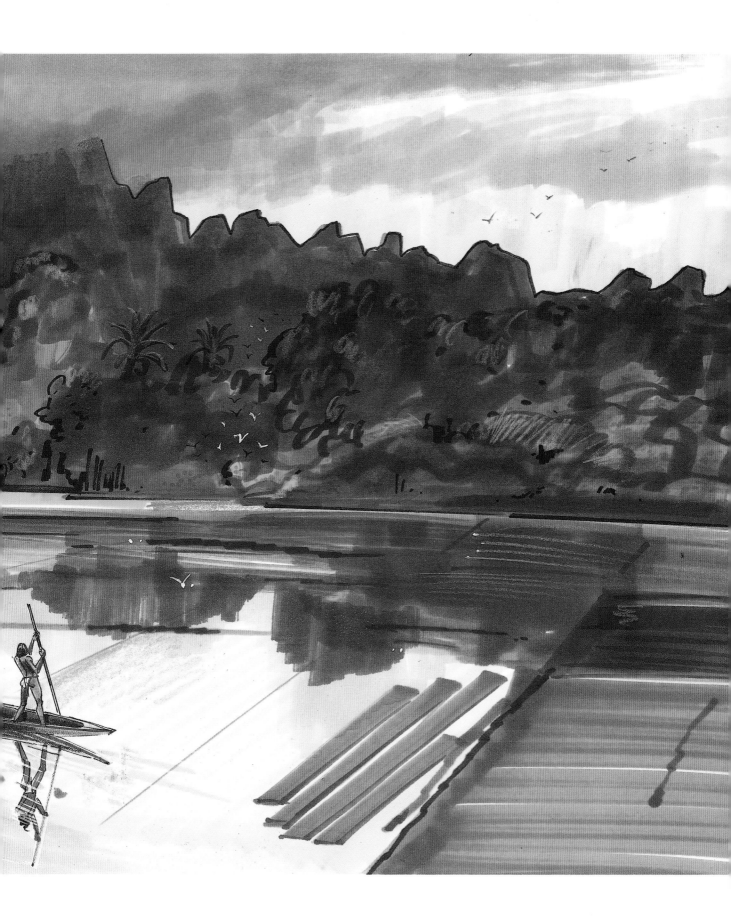

Demonstration: Blending

For this exercise, be sure your markers are loaded and the caps are off so you can quickly change to another color while the preceding one is still wet. When you are finished with a group of colors, always return the caps immediately, and be sure they snap into place.

Begin by laying in the lighter tones first, and immediately follow by laying in the darkest values against them. Alternate between the two, going back and forth over the edges if necessary until they soften and blend.

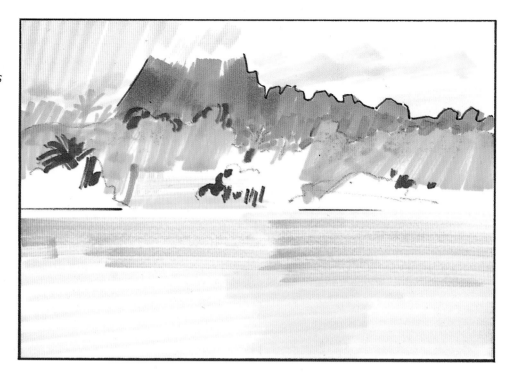

Now lay in the middle tones, being sure to keep the surface wet. Use a blender or very light-valued marker like light ivy, ice blue, or buff, and cover whole areas to sweep them together. Lastly, go back in with pastel or colored pencil if you're not satisfied. Use opaque colored pencil or paint to add a finished look.

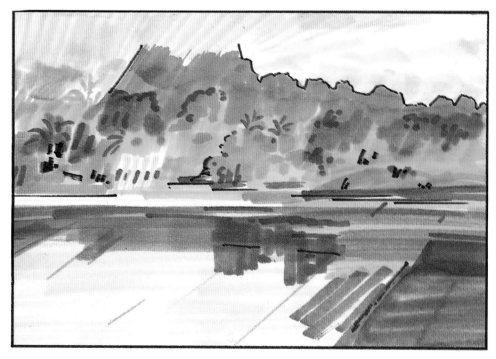

When doing marker illustrations, you must organize and simplify. The black edge reminds us that our responsibility is not to outdo nature, but simply to capitalize on its beauty.

First lay in all the hard lines and the dark background. Now you can see where you must blend. Uncap ice blue, mauve, and pale indigo. Work back and forth, keeping the surface wet, and aim for softness.

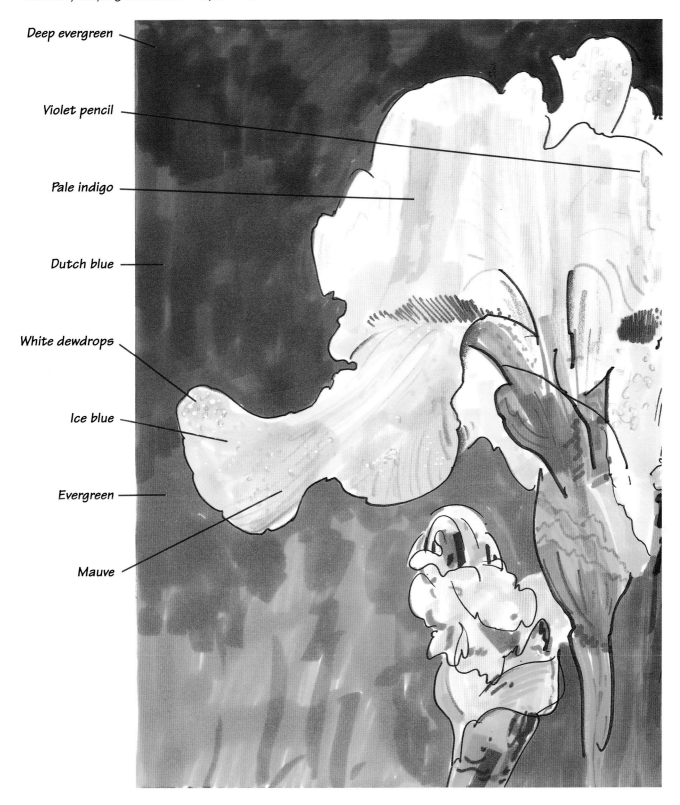

Deep evergreen

Violet pencil

Pale indigo

Dutch blue

White dewdrops

Ice blue

Evergreen

Mauve

GLAZING

A glaze is a thin, transparent wash. Glazing consists of laying down a base color, usually a bright color, then overlaying it with successive thin layers of light color. Glazing over darks will soften them to a degree, particularly super black, because it tends to drag some of the color into the white area.

To get the effect of a glaze while still retaining some of the original base color, you can glaze over only part of the base color. This technique is called partial glazing, and the bottom three fish on the facing page were done this way.

The best surface for glazing is a paper like Bienfang 360, a low-porosity surface that permits the application of light colors. This is the first requirement for successful marker glazes. Since porous papers darken colors, getting light, bright base colors and thin, delicate pastel glazes would be difficult at best.

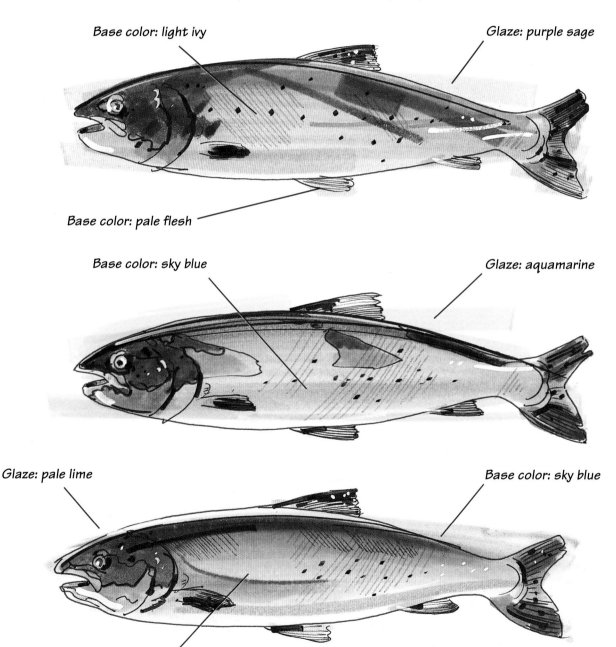

Base color: light ivy

Glaze: purple sage

Base color: pale flesh

Base color: sky blue

Glaze: aquamarine

Glaze: pale lime

Base color: sky blue

Base color: flesh

EXERCISE:

Beginning with a drawing like this one, try these glazing variations to familiarize yourself with the behavior of markers as glazes. Concentrate on using only a single stroke application to retain the purity of the glaze and ensure transparency.

Glaze: mauve

Base color: ice blue

Base color: light ivy

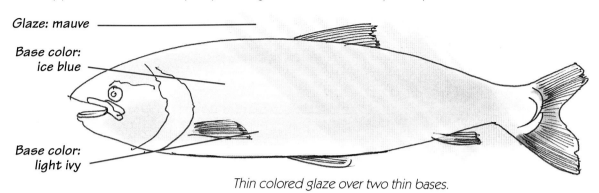

Thin colored glaze over two thin bases.

Partial glaze: peach Painted highlights Black shadow Base color: ice blue Black accents

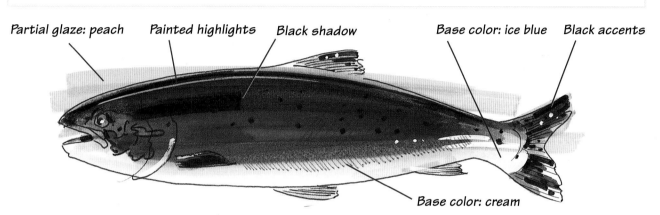

Base color: cream

Glaze: pale indigo Base color: ice blue Base color: cream

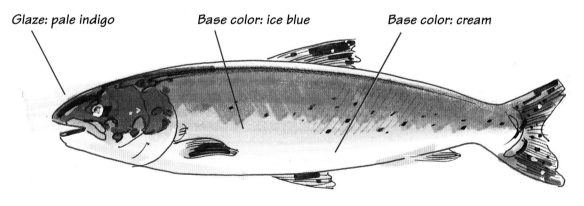

Partial glaze: suntan Base color: pale indigo Base color: flesh

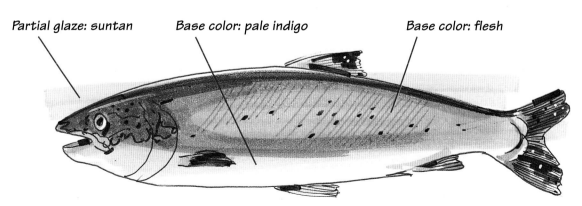

Skin Glazing

Glazing is marvelous for building color, shadow, and values in many subjects, including skin. We glaze with markers for the same reason painters have always glazed: to build depth and richness; to let colors shine through successive layers of paint. Don't use too many layers—three or four is plenty—or you will lose transparency.

Use Bienfang 360 or some other low-porosity paper. Begin by laying in a base over which to glaze. Go right over the eyes and glasses.

Peach is a little strong for skin, but an excellent base color for luminosity.

Use redwood to begin blocking in the face immediately by laying in darks.

Deep salmon

The "beard" is cool gray no. 3. Add pale sepia as a base for the hair. The forehead is sunset pink, a very pale pink.

Chrome orange is also a little warm for skin, but it will be just right for penetrating the skin glaze.

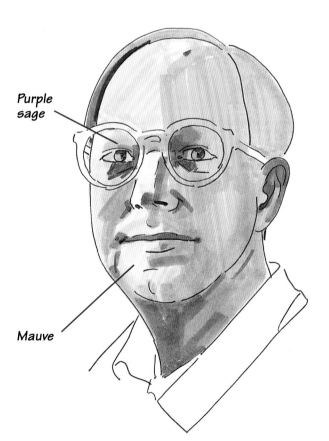

Purple sage

Mauve

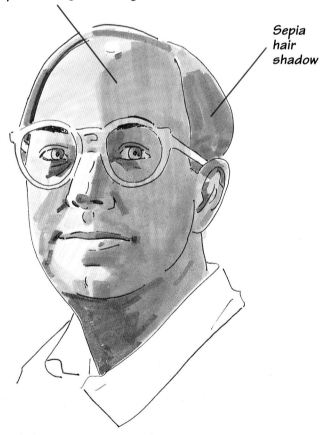

Sepia hair shadow

It's best to make a single sweep with the marker from left to right. That will give you the lightest coat with the greatest translucency. Don't be afraid to use colored pencil later to blend, soften color, or add texture.

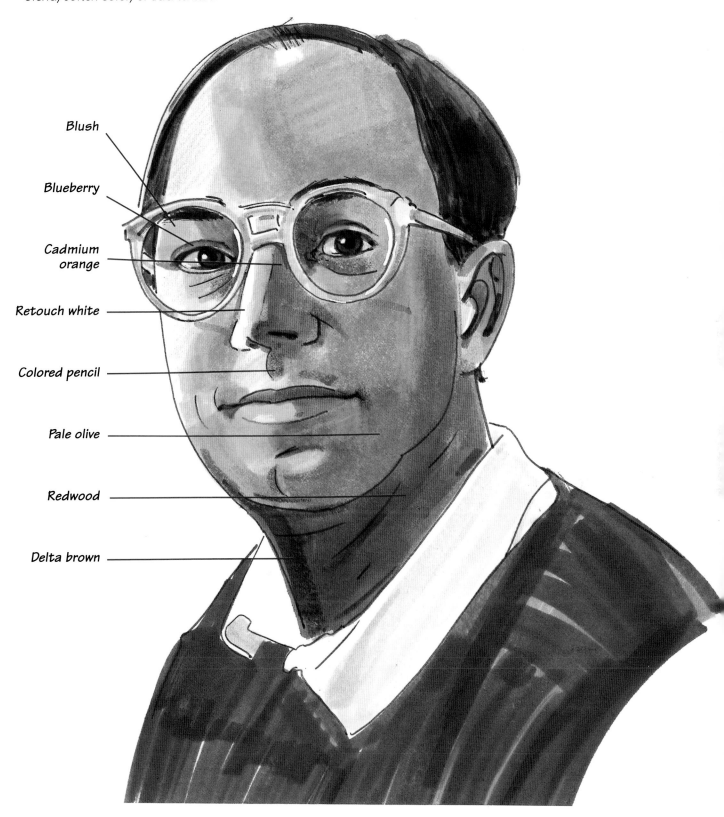

Blush

Blueberry

Cadmium orange

Retouch white

Colored pencil

Pale olive

Redwood

Delta brown

MIXING MEDIUMS AND TECHNIQUES

Here's your chance to incorporate all your favorite tools. Study the different effects you can achieve with a wide assortment of techniques.

Crayons are still an excellent product and very inexpensive. They work well when applied over markers, because the crayons are not opaque and will not block the white of the paper or the marker color below.

Crosshatch, hatching, splatter, retouch white, colored pencils, smearing blacks—as well as other techniques explained earlier in this book—all is fair in the painting game. We're not marker purists—or are we? Don't be afraid to try all these techniques, plus anything else that works. Be inventive.

Never forget the basic black line, which can be used in so many variations. It will always be your secret weapon.

Smearing

Hairline—an extra-fine line, using a Berol Thinliner or a Marvy Le Pen

Splatter—white

Berol Boldmaster, side of nib

Splatter—dark

Colored pencil

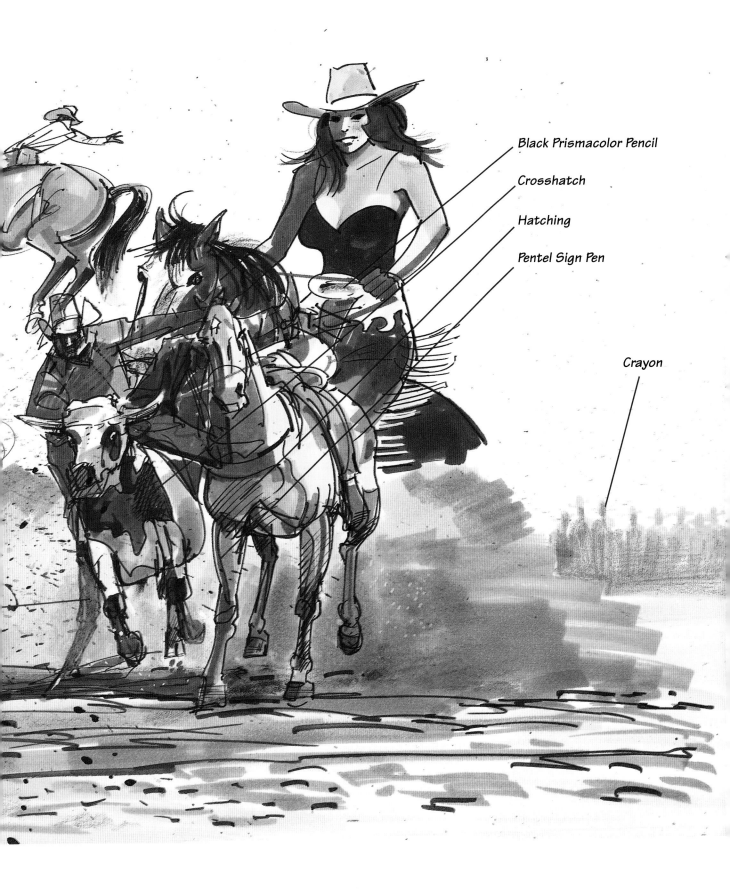

Black Prismacolor Pencil

Crosshatch

Hatching

Pentel Sign Pen

Crayon

Combining Markers with Colored Pencils

Colored pencils and markers work extremely well together. Pencils can be used both as a secondary technique and as a major method of finessing an illustration. Their textural quality is similar to that of dry markers, but they are much better for rendering or "tightening up." When you have completed your marker portion of an illustration, look at each area to see if the pencil texture would enhance or improve it.

Another big advantage of pencils is the large assortment. Berol makes 120 Prismacolor pencils and 48 sticks. Although the pencils are well known, the sticks are a well-kept secret. They contain the same material as the pencils but are like NuPastel sticks in form and can be used to cover large areas quickly and cleanly. Work with the largest palette possible, and with the full range close at hand.

This illustration employs both wet and dry markers in the conventional style. The dry markers serve somewhat the same purpose as colored pencils in the adjacent treatment.

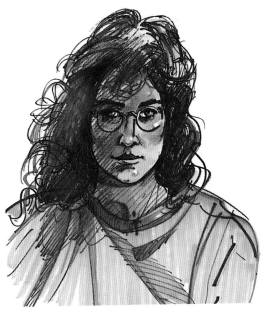

Here colored pencils have been used extensively—as drybrush, in a sense—to enhance the flatness of the marker washes and to render further. The pencils also add a softness that is quite handsome.

Use black as a strong accent as well as a confining or delineating line. In effect it "punches out" an area by representing a strong shadow behind the object.

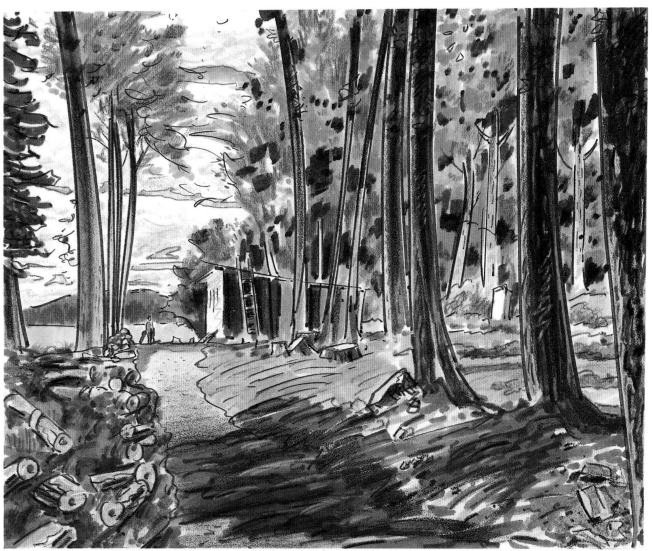

Notice the added use of colored pencil. Although subtle, it gives the picture another dimension. Light pencil over dark marker is opaque.

USING LINE FOR ALL IT'S WORTH

Although black line does not exist in nature, it is one of your most important tools. A drawing is actually pure fabrication, a reconstruction, and black outlines isolate and call attention to the subject.

It's important to use a range of black lines. The easiest way to do that is to have a variety of points—for example, Marvy Le Pen, Berol Boldliner, Pentel Sign Pen, and Design Art Marker #229. Don't be afraid to use the side of the nib for boldness, or bear down for a thicker line. Remember to trade safety for strength; timid correctness in drawing is less a virtue than a weakness, and markers were designed for a bold, aggressive approach. Also, try using the side of the nib at a slight angle and the point against a straightedge. It will give you a hard edge on one side and a ragged edge on the opposite side.

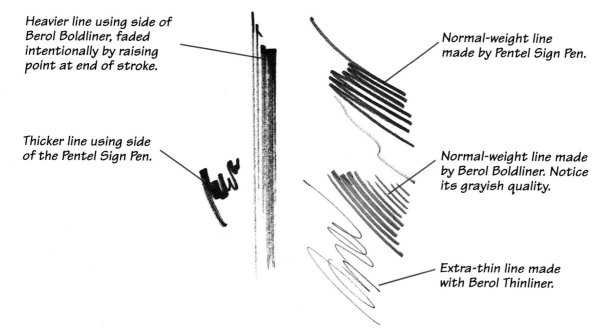

Heavier line using side of Berol Boldliner, faded intentionally by raising point at end of stroke.

Thicker line using side of the Pentel Sign Pen.

Normal-weight line made by Pentel Sign Pen.

Normal-weight line made by Berol Boldliner. Notice its grayish quality.

Extra-thin line made with Berol Thinliner.

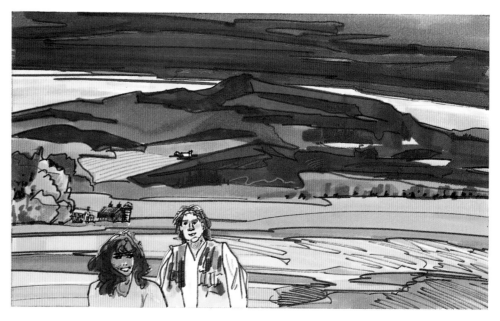

I used a strong, black line here to separate color areas, strengthening the joining edges. The effect is like that of a molding: It emphasizes the straight line formed by the wall and adjoining ceiling, and it looks good. The people were done separately and then attached to the background, making an uninterrupted flow of background lines possible.

How to Begin

I recommend that you try drawing directly with the pen instead of beginning with a pencil drawing. A precise underdrawing is often necessary for some illustration subjects, but when spirit and dash are important, try working directly with pen, eliminating the underdrawing. It's a simple matter to correct small mistakes or to upgrade certain sections by adding a darker marker color to cover the area. Opaque white is also a big help, and of course patching is always an easy option. For more about invisible patching, see page 142. That's one of the big advantages of markers. Don't be afraid to capitalize on it.

Once you have both line and the first wash in place, continue building colors, aiming for real strength in both color and value. Then go back to a fine or medium pen and finesse the line work where needed. Correct, add to, strengthen the line drawing. Work back and forth between line and color until you're satisfied.

The persistent use of line in this drawing is obvious. Almost every element is outlined and thus separated from adjacent colors.

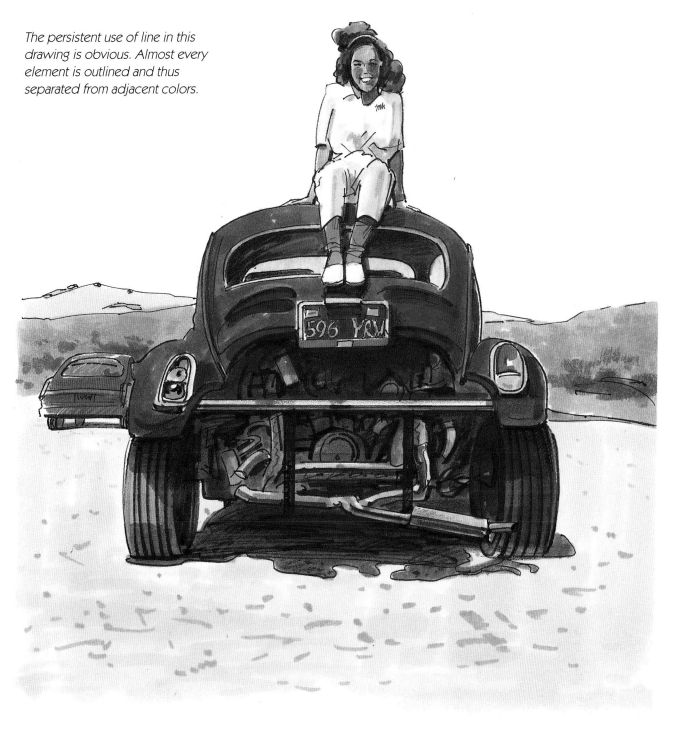

Basic Black Line

Never lose sight of the wide range of weight, color, and variety line offers. Always consider one line against another —curved against straight, thin against thick, gray against black. Or is there an advantage to using a colored line?

Even a single pen should be used with different pressures and angles to give you the thickness you want. Only you can control the pen. Study the great variety demonstrated by only a few pens on these two pages.

Always keep a few different pens in your pocket and use them all.

Line plays an important role in this illustration. The color would not mean much without the strong use of line. I used the side of a Berol Boldliner nib forcefully, holding the pen at a slight angle to the paper and pressing very hard. It's important to get the most possible out of the pen.

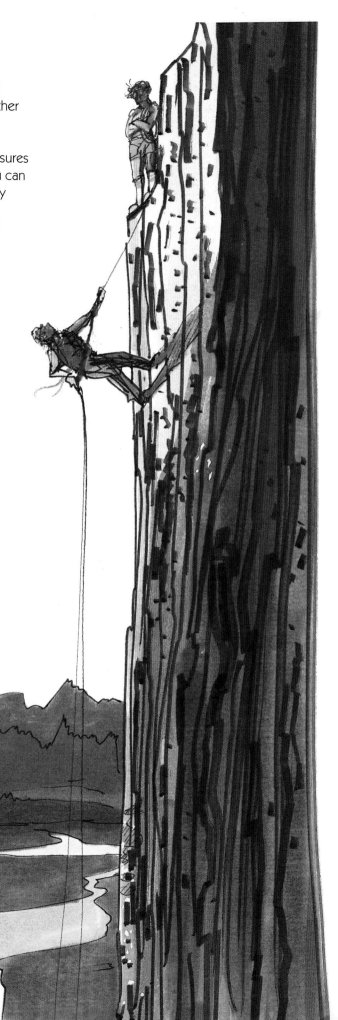

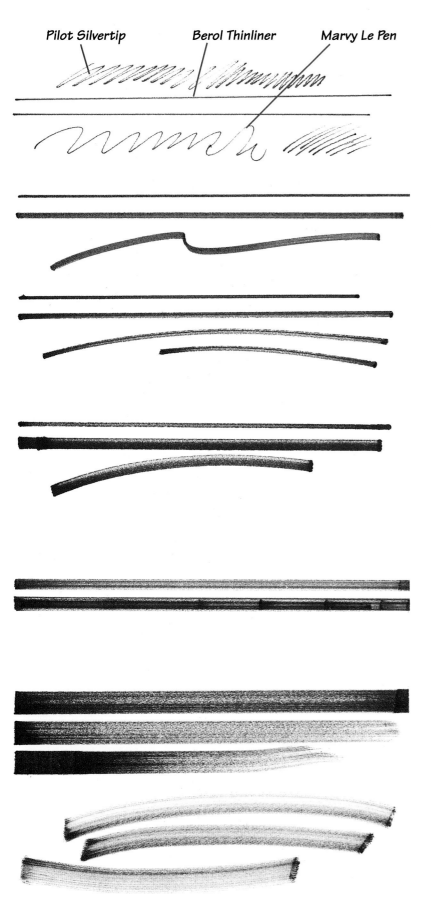

Pilot Silvertip **Berol Thinliner** **Marvy Le Pen**

These three pens offer the cleanest fine lines available. They make a necessary foil to heavier pens and will not pick up fibers of the paper.

Berol Boldliner is a versatile, medium pen with a soft tip. It has wide flexibility and is not jet black. The point has a broad side when used at an angle.

The Pentel Sign Pen is very utilitarian. It is black, with a handsome gray effect when partially dried. Hold it lightly between your thumb and forefinger for a very thin line, or bear down for a thicker line. Use the side of the point for texture and width.

Design Art Marker 229LF is another high-quality pen. You can change the width of the line by bearing down or using the side of the nib. It dries quickly if not put to the paper immediately, facilitating the use of either a dry or wet line. However, it will run if overlaid with color, so always use it after the color is in place.

Marvy Chisel Point (Calligraphy Pen) is a fine-quality pen with a very clean line. It is also great for grading from black to a lighter value. The 3.5 and 5.0 mm (1/8" and 3/16") widths are shown here.

Pentalic Lettering Marker with 5/16" (0.8 cm) chiseled nib is a good, wide, chisel-point nib for either large letters or a broad, crisp line.

The Pentalic Lettering Marker is also great dry, as shown here.

The Straightedge

Did you notice how powerful the lines demonstrated on the preceding page were? The straightedge—in that case, a T-square—was one reason. A straight line has power and force. Always use a straightedge for drawing straight lines. It takes a little more time, but it's worth it. Be careful to clean the edge often, however, because it will pick up the ink and transfer it to your fingers. And you know where it goes next: onto the drawing! You can also use a narrow strip of illustration board in place of a ruler. It will tend to absorb and hold the ink—at least for a while.

Once your straight lines are in place, add curved lines or shapes nearby to make them look even straighter.

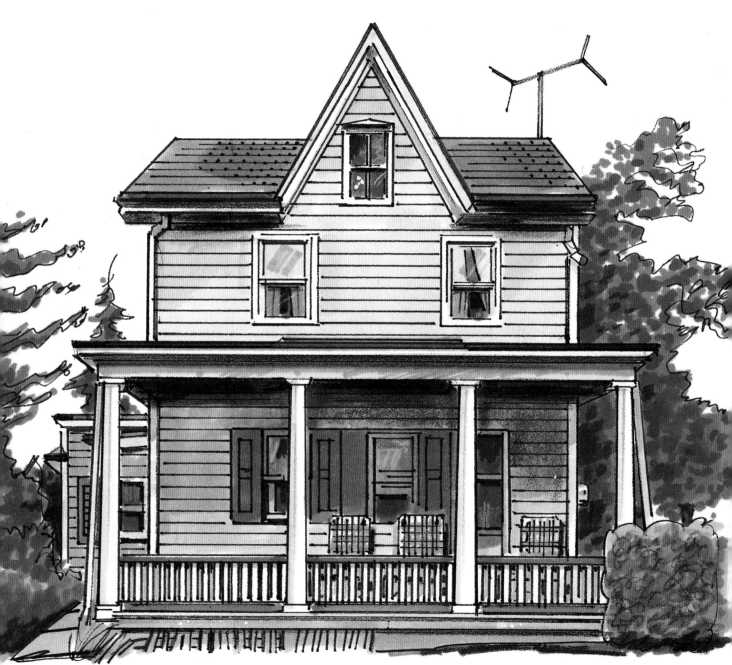

This tiny house is solid and monumental. I used the tip and the tip edge of a Berol Boldliner and a worn-out Pentel Sign Pen to give me a soft line.

This illustration could easily have been done without a straightedge, but it would miss the whole idea of building a tiny house with great power and stability.

Not only do the straight lines work nicely against the soft foliage, they also state with authority the incredible height and reinforce the feeling of danger. I used three weights of black line in this illustration.

Berol Thinliner

Black Pentel Sign Pen

Black Prismacolor pencil

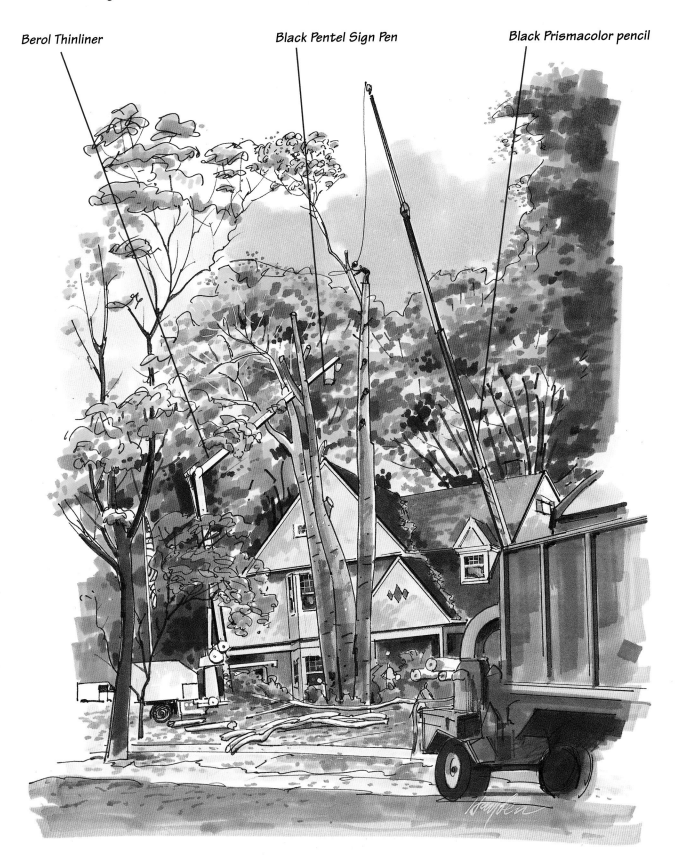

Outlining

Line is the backbone of illustration. Weak or strong, it's the frame that holds the figure together. Any strong line drawing stands on its own, but it makes an even stronger statement with marker. The softness of the marker wash flatters and emphasizes the force of a decisive black line.

EXERCISE:

Do a freehand copy of the illustration on this page, or draw another figure study of a model in a different pose. Study the texture of the line shown here, and choose a marker that will dry during the stroke to give you a wet-to-dry look. Make your line drawing quick and bold! Capture gesture, not detail.

The same spirit displayed in this line illustration influences the manner in which the marker is applied to the skin and hair. This is a good way to develop a strong single marker stroke. Color here becomes secondary to the powerful line treatment, but still enhances it.

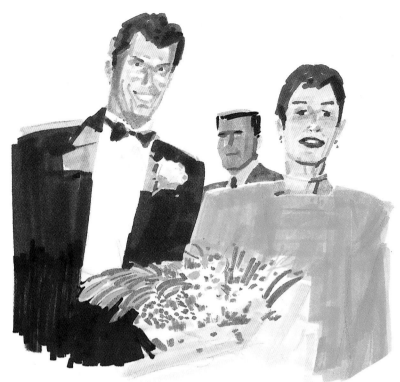

To give you an idea of how an outline will make the subject stand out, I prepared a lineless sketch. Then I redrew the sketch beginning with a pen drawing and added color. Very little time was spent on either one, but notice how quickly the line version asserts itself. True, I could have developed the lineless sketch further, but it would never have the snap that the lined version shows almost immediately.

EXERCISE:

Satisfy yourself about the usefulness of line by trying both versions of the illustration on this page. Slip them under your marker paper, trace them with a pencil, and then remove your drawing and refine it with marker color, using the printed illustration for visual reference. Do the lineless version first, then brace it with bold black line.

Next try redoing the illustrations just by looking at the illustrations, not tracing them. It's good to work this way often to reassure yourself that you're capable of transferring proportions accurately.

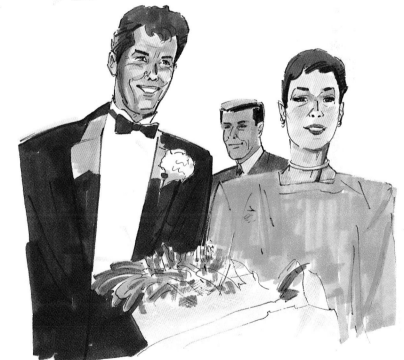

Heavy Line

A heavy line is a dynamic force in marker illustrations. It quickly makes an important statement and becomes a strong framework that supports thinner line and color. You shouldn't feel that your drawing style incorporates only heavy line or only a thin, delicate line. Alter your style depending on the need. It will make your work more engaging. Keep your style looking fresh.

Dry Design Art Marker 229LF

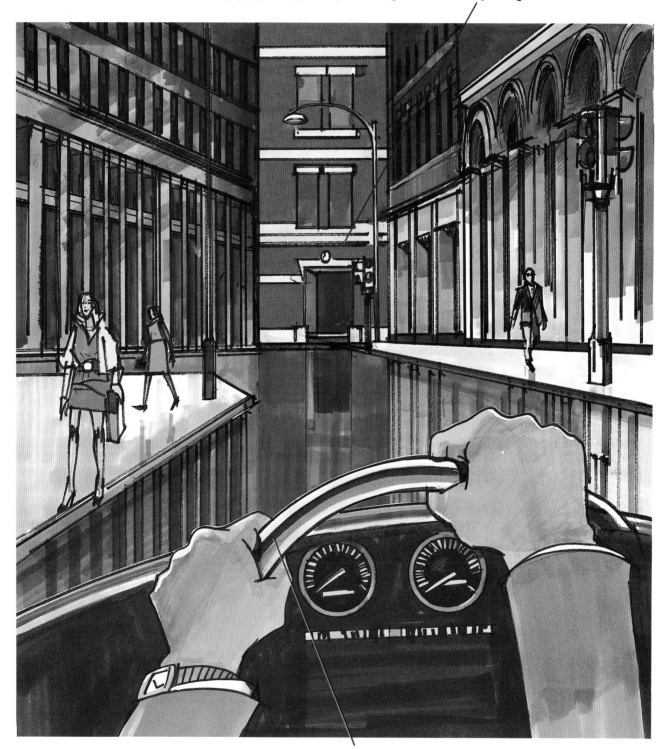

Pentel Sign Pen

Going back into this
drawing with a heavy
line makes an
otherwise mundane
profile a compelling
statement.

Notice how I avoided
lines in the dress,
maximizing the force
of the strengthened
lines of the arms
and legs.

Don't make both
sides of the arm
equal in weight.
Add weight to
the shadow side.

Throw the far leg
almost totally
into shadow, even
though in reality
it is about the
same value as the
other leg.

Add a strong blue
—Dutch blue—as
a shadow for the
left leg.

PUSHING PERSPECTIVE

Perspective is another important opportunity to "bend the rules" and dramatize the subject. By exaggerating actual perspective angles, we immediately introduce a feeling of movement, even speed, as the perspective quickly decreases in size or fades perceptibly. Reflective clouds in the facade also seem to exaggerate height.

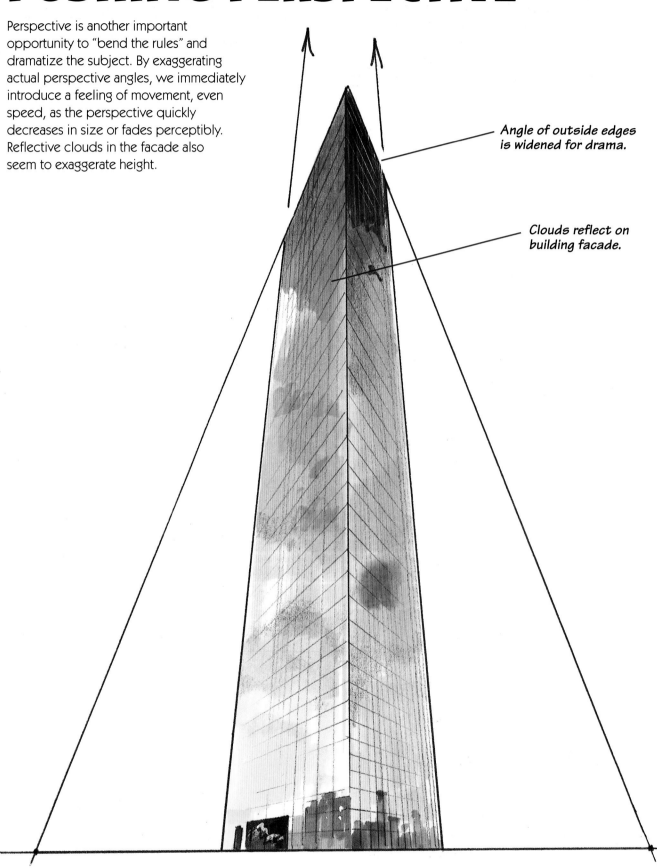

Angle of outside edges is widened for drama.

Clouds reflect on building facade.

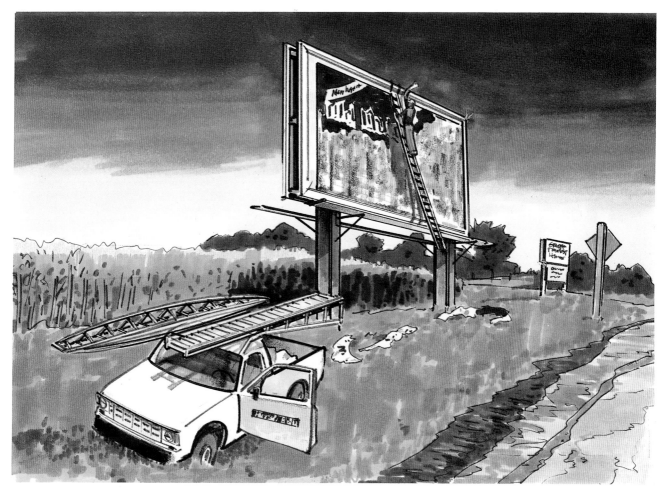

A wide-angle camera lens distorts normal perspective lines. We notice this particularly with faces and with rectangular objects. Here is an example of the latter.

Two principal subjects—the truck and the billboard—were used here to take advantage of double sets of vanishing points. Within the comparatively short width of the subjects (as compared to a building), there is still powerful perspective distortion. Even the truck door is exaggerated to take advantage of perspective.

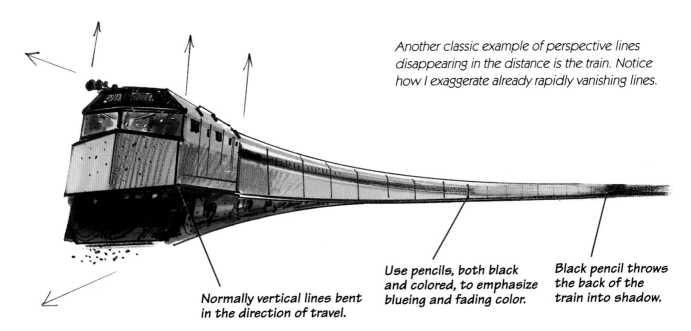

Another classic example of perspective lines disappearing in the distance is the train. Notice how I exaggerate already rapidly vanishing lines.

Normally vertical lines bent in the direction of travel.

Use pencils, both black and colored, to emphasize blueing and fading color.

Black pencil throws the back of the train into shadow.

THE FACE

The human face is a highly appealing subject, one that naturally draws the viewer's eye. It is a subject essential to the advertising industry, so it pays to become skilled at drawing faces!

 Because the face is a complex subject, organizing and simplifying are crucial. You must also decide how much time you have to devote to a particular illustration. You can suggest a face very quickly, or render it in far more detail, using many colors to achieve a much closer approximation to reality.

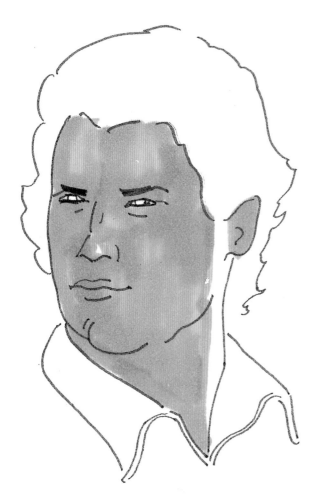

Notice how simply the face is treated here: one color plus line. This in itself could be adequate. The features are drawn using symbols, instead of being rendered.

To build more dimension and interest, it's hard to resist adding a shadow. Nature never fails to light one side and shadow the other, no matter how complex the planes. But this could also be a difficult kind of indication to complete in a reasonable time, so we simplify it, letting light strike a larger area and limiting the shadow to one or two planes.

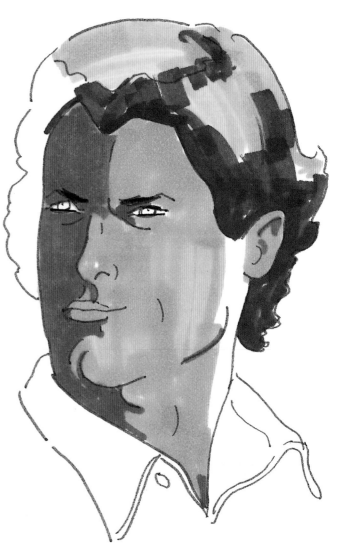

Now since there's some time remaining, and there often is, we'll devote it to the process of developing color and shadow.

Make the shaded areas heavy and accent the recesses—nostrils, lip shadows, eye recesses. This makes the lighter areas more noticeable.

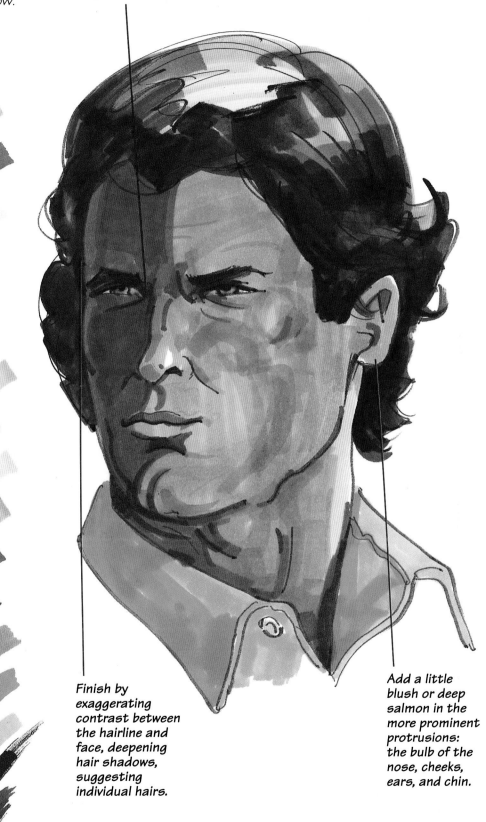

Blush

Redwood

Cool gray no. 1

Delta brown

Deep salmon

Pale sepia

Process blue

Flesh

Desert tan

Redwood

Delta brown

Mocha

Viridian

Aqua

Black

Prussian blue

Finish by exaggerating contrast between the hairline and face, deepening hair shadows, suggesting individual hairs.

Add a little blush or deep salmon in the more prominent protrusions: the bulb of the nose, cheeks, ears, and chin.

What Color Is a Face?

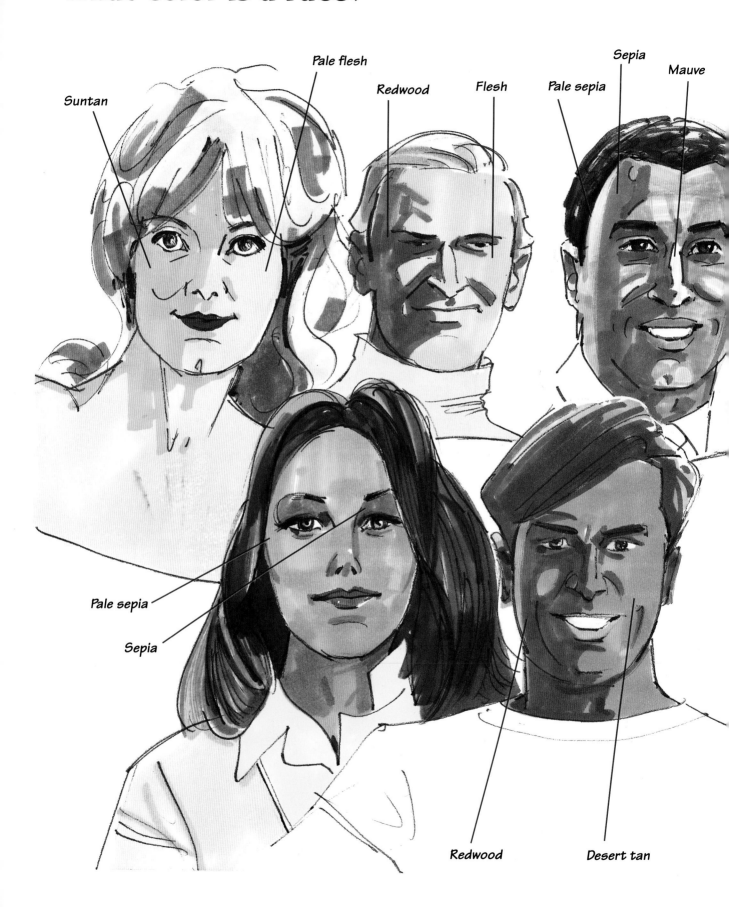

Suntan

Pale flesh

Redwood

Flesh

Pale sepia

Sepia

Mauve

Pale sepia

Sepia

Redwood

Desert tan

Now concentrate on some of the more common skin color variations and use them to broaden your knowledge of the scope of markers in expressing the character of skin.

Always paint the face in solid—no whites—before adding shadow. Stick with colors that have some basis in fact. In truth, as long as you follow these simple combinations, you'll never get in trouble.

Never be without your skin colors. It's next to impossible to substitute other colors for the real thing.

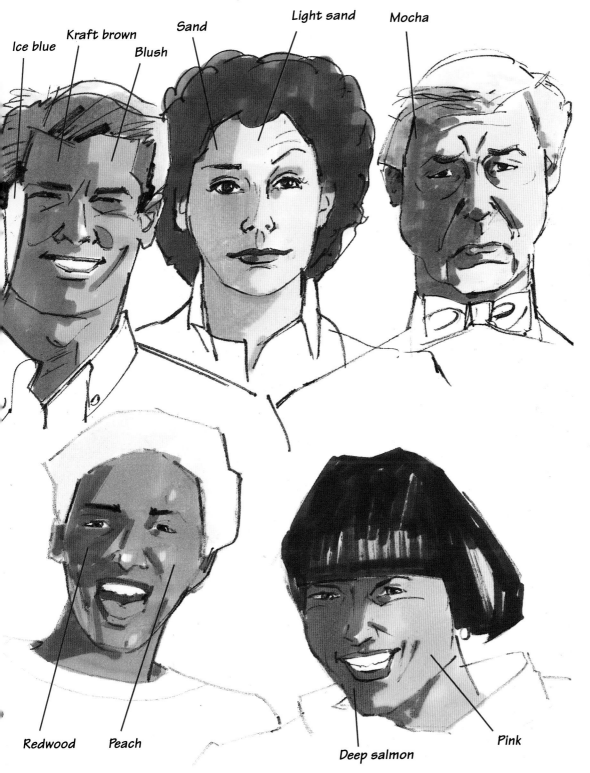

Lighting the Face

This is a pretty diverse subject, but we're going to simplify it into these principal common lighting situations. Some are more useful than others. There are many varieties. The three-quarter front demonstrated here first is one of the most common.

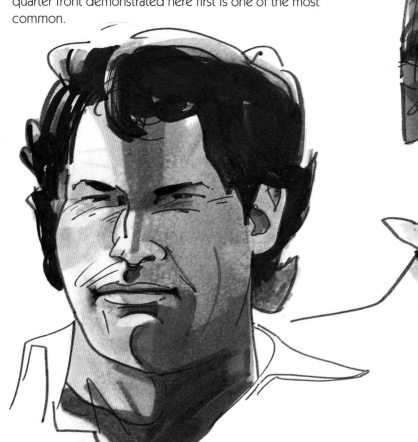

Three-quarter lighting comes from about 45 degrees to the front, so that one side of the face is in light, the other in shadow. Try this lighting method first. It's probably the easiest and very effective.

Edge lighting gives the slightest suggestion of the facial form by light striking the side only.

Edge shadow is the opposite of edge lighting, with just enough shadow at the edge of the face to define the shape. Turn the shadow on the nose and face with a black line.

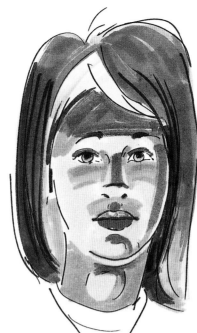

Bottom lighting was recently made popular by the fashion drawings of Jim Howard. The opposite of the usual overhead lighting, it's a difficult source to use without looking somber. However, when used well it is stunning.

Backlighting is a powerful effect, but it must be used with a dark background. I often use it to simplify large groups or to shift emphasis to other subjects, because it gives less definition to the face. Use "calligraphy" throughout to define the features: Invent symbols for the eyes, nose, and mouth, and use just enough wrinkles to define the action of the face a little.

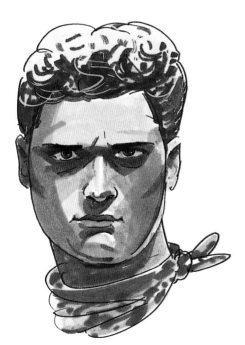

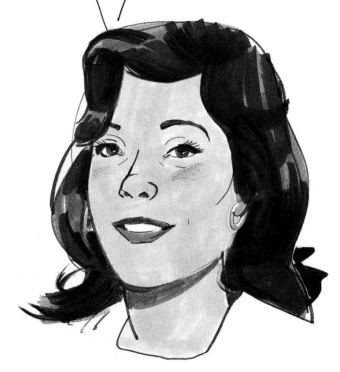

Frontal lighting occurs when the light source shines straight into the subject's face, leaving no shadows to help you define form. You can't avoid this one. Even so, I always throw the neck into shadow to set off the face.

Top lighting is not always a flattering source. It's what you see on the beach at noon—hard eye and nose shadows, a "hot weather" light source. Even though the shadows are usually very dark, you can soften them to make the result less jarring.

Eyes

Drawing the eye is another giant leap of simplification. Eyes are often oversized and overly rendered by illustrators. Shown here are several examples of indicating and suggesting eyes. Making them squint or coloring them with glasses are good ways to get variety into your work.

Eyes are rarely seen dead on, and the whites are often far from white. Take advantage of these facts to make your illustration even more interesting. Here the eye is done simply, with white only in the highlight. Color is added outside the eye. Lids are darker than the pupil.

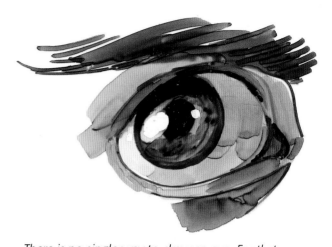

There is no single way to draw an eye. For that reason I've applied my experience and added as much color inside and outside the eye as I possibly can. But this procedure is always based on things I have noticed about the eye in paintings, photographs, and real life.

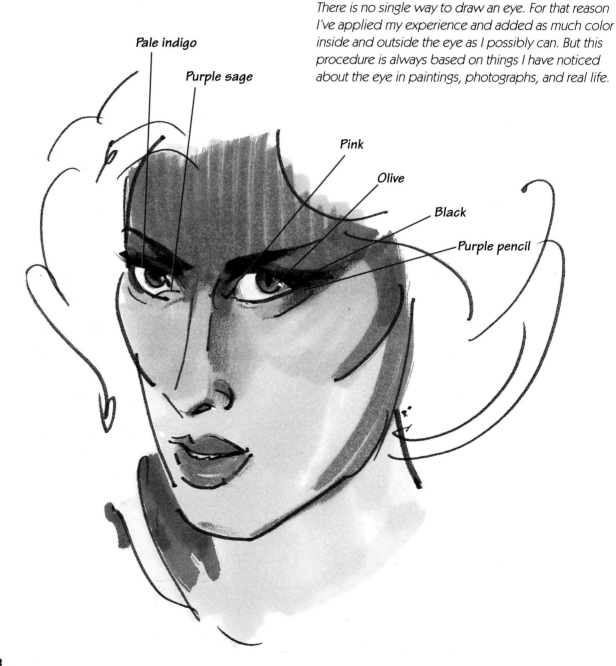

Pale indigo

Purple sage

Pink

Olive

Black

Purple pencil

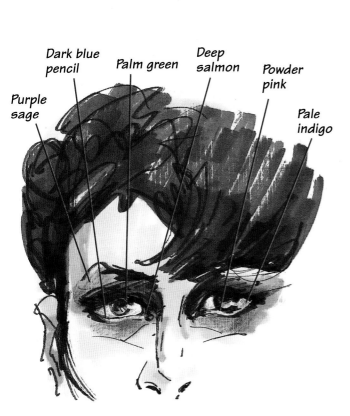

Purple
sage

Dark blue
pencil

Palm green

Deep
salmon

Powder
pink

Pale
indigo

In this laughing face, the eye almost entirely
disappears and becomes more of a line than an eye.
This makes it easier to draw. You can indicate the eye
with a single line, then go back into it and add more
detail as desired.

Here is another treatment using
colored pencil, Pentel pen, and
markers. Notice that the eye is
separated from the face by dark
eyelids and accented lashes.

Regular glasses are usually clear and
do not affect the eyes and skin color.
Of course, if you prefer, you can add
color to glasses or throw the eyes
into shadow. This gives you the
opportunity to have fun with
highlights and shadows on the glass.

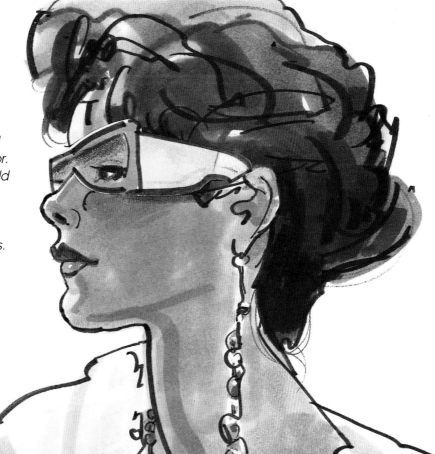

Hair

Blond hair is usually everything *but* yellow. Even so, I normally add yellow because it's colorful. A closer marker color would be something like light ivy or cream in the highlights. The darks would be delta brown with black accents in the deep shadows. Middle values would run between chrome orange and sepia; even olive greens are often present in the blond range.

The same is true of other hair colors. Red hair, for example, is not red but usually goldenrod to chrome orange. But it would have touches of cadmium red, burnt sienna, delta brown, maroon, and black. Flip through this book to see how I've treated a few other hair colors.

If you use imagination and flair, the colors don't have to be strictly accurate to be striking and believable. The important thing is to make it move and tumble, letting either the darks or lights dominate.

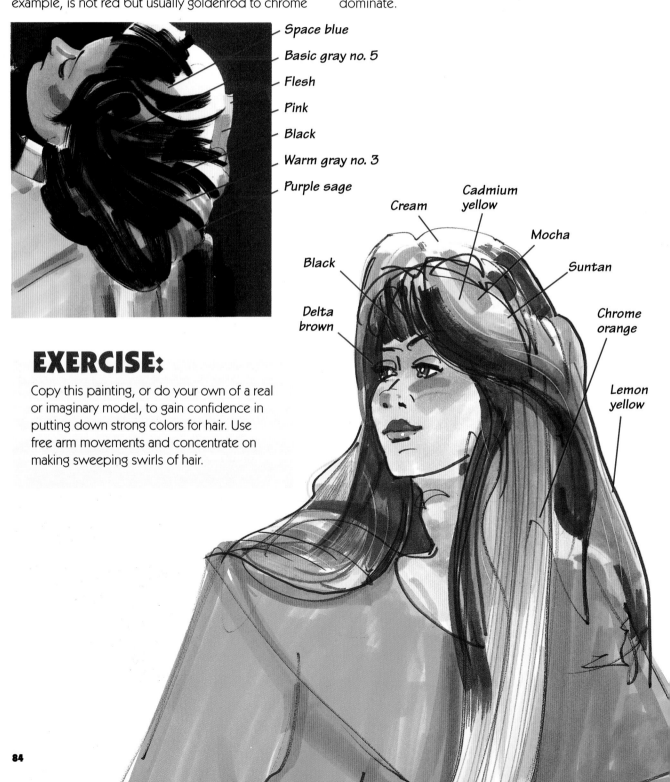

Space blue
Basic gray no. 5
Flesh
Pink
Black
Warm gray no. 3
Purple sage

Cream
Cadmium yellow
Mocha
Black
Suntan
Delta brown
Chrome orange
Lemon yellow

EXERCISE:

Copy this painting, or do your own of a real or imaginary model, to gain confidence in putting down strong colors for hair. Use free arm movements and concentrate on making sweeping swirls of hair.

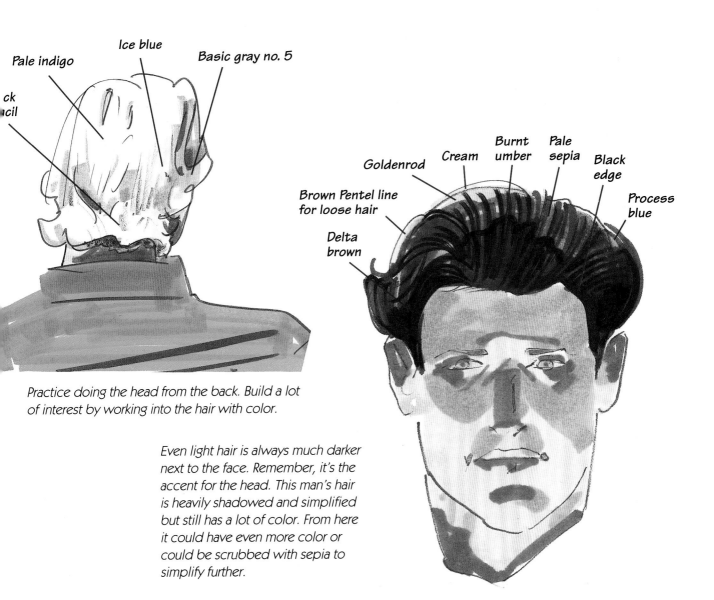

Pale indigo

Ice blue

Basic gray no. 5

ck
cil

Goldenrod

Cream

Burnt umber

Pale sepia

Black edge

Brown Pentel line for loose hair

Process blue

Delta brown

Practice doing the head from the back. Build a lot of interest by working into the hair with color.

Even light hair is always much darker next to the face. Remember, it's the accent for the head. This man's hair is heavily shadowed and simplified but still has a lot of color. From here it could have even more color or could be scrubbed with sepia to simplify further.

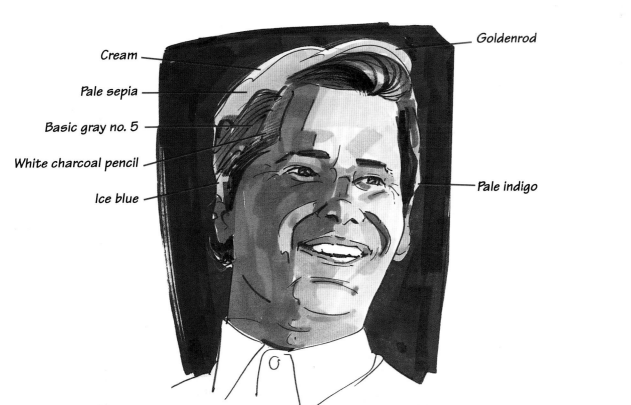

Cream

Goldenrod

Pale sepia

Basic gray no. 5

White charcoal pencil

Ice blue

Pale indigo

THE FIGURE

The human body is a complex but highly appealing subject with its own unique challenges. It is always in motion, always changing with every nuance of light and angle. To capture the look of the human figure with markers, you must paint smart and paint simple.

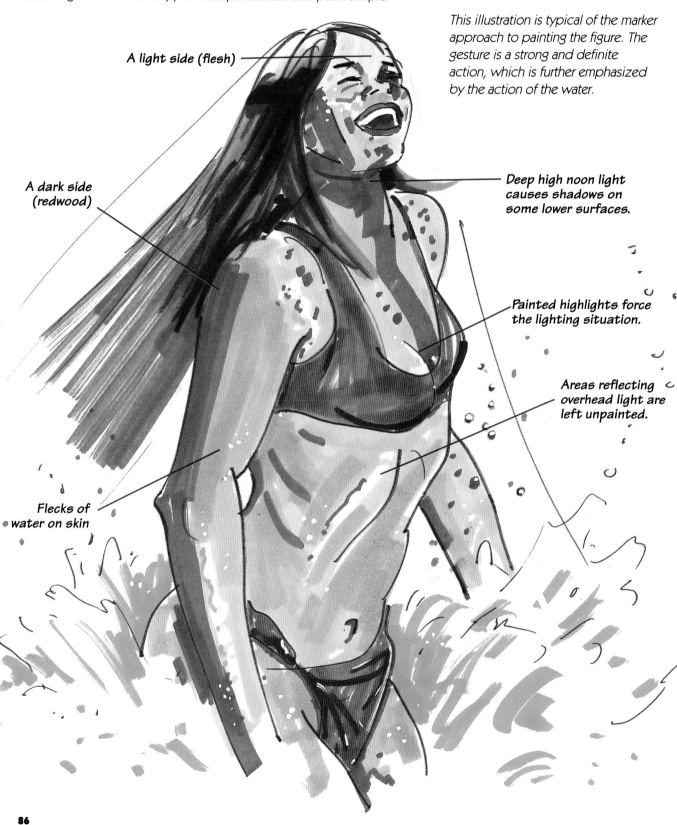

This illustration is typical of the marker approach to painting the figure. The gesture is a strong and definite action, which is further emphasized by the action of the water.

A light side (flesh)

A dark side (redwood)

Deep high noon light causes shadows on some lower surfaces.

Painted highlights force the lighting situation.

Areas reflecting overhead light are left unpainted.

Flecks of water on skin

Drawing the Figure from Memory

Form the habit of drawing from memory often. It forces you to memorize and recall. It's a skill easily acquired with a little practice, and it will train you to concentrate on the most essential elements of the figure. Suddenly you're drawing like a child—recording only the most important aspects of the figure, from memory and with refreshing spontaneity! I often go back later to the original subject to check my memory for accuracy.

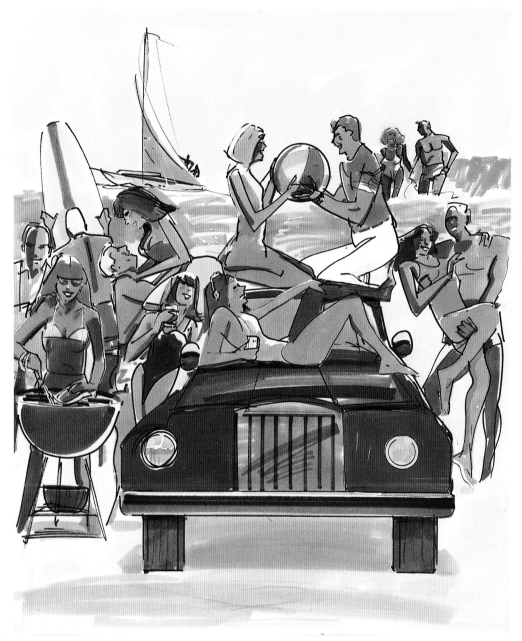

This is a 30-minute sketch painted from memory. I enjoy working under pressure because it forces me to think about and exaggerate gesture. Then on top of the gesture, I build the figure—clothing, props, and so on.

EXERCISE:

Think about a scene you can remember, one that contains several figures in different poses. Draw a sketch of it in 30 minutes. You may wish to redo it to correct any inaccuracies of proportion or awkward gestures. If you are pleased with your basic sketch, go ahead and refine it into a more finished painting.

The Figure at Rest

Actually, there's no such thing. Even relaxing, the figure is dynamic. Be familiar with indicating people "hanging out." For every part of the body in stress, there's always an opposing part at rest.

Shown here are some familiar "at rest" positions using gesture, light, and shadow in a simple format. Use light and dark with each body section, and be sparing with stress lines. Follow my simple break-up of color and line.

Light side: pink, lemon yellow, pale sepia, deep evergreen, pink, redwood

Dark side: pale sepia, deep salmon, deep evergreen

There are many ways to fold the arms and many angles to draw. Get used to the position and simplify your marker interpretation.

Dark side: warm gray no. 3, evergreen, cadmium red, redwood

Light side: light ivy, Pantone green M, pink, cadmium red, kraft brown

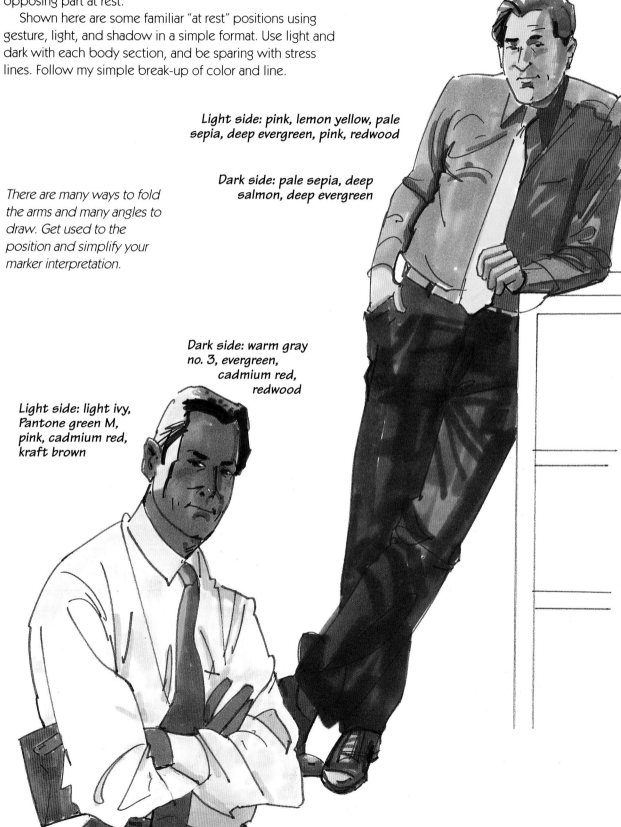

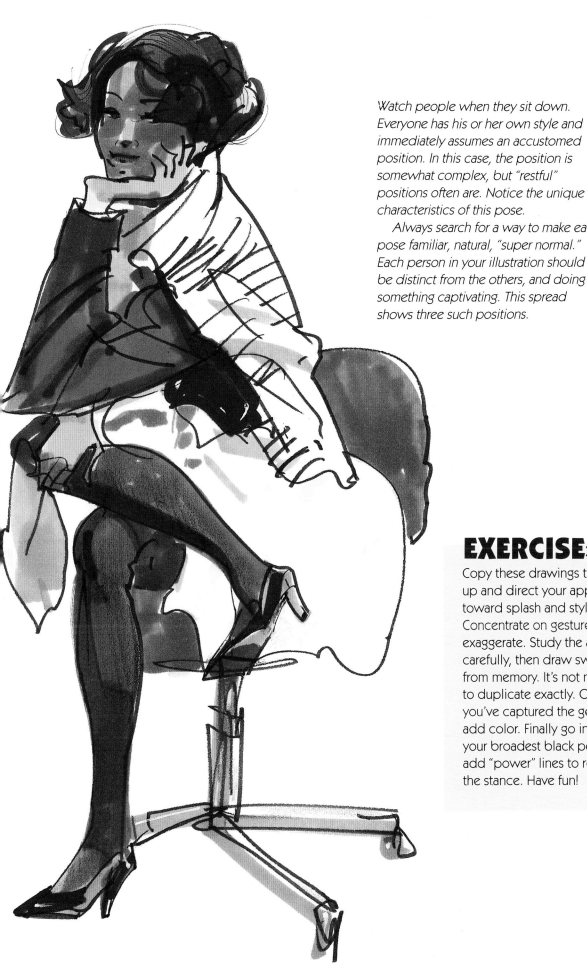

Watch people when they sit down. Everyone has his or her own style and immediately assumes an accustomed position. In this case, the position is somewhat complex, but "restful" positions often are. Notice the unique characteristics of this pose.

Always search for a way to make each pose familiar, natural, "super normal." Each person in your illustration should be distinct from the others, and doing something captivating. This spread shows three such positions.

EXERCISE:

Copy these drawings to loosen up and direct your approach toward splash and style. Concentrate on gesture— exaggerate. Study the attitude carefully, then draw swiftly from memory. It's not necessary to duplicate exactly. Once you've captured the gesture, add color. Finally go in with your broadest black pen and add "power" lines to reinforce the stance. Have fun!

The Fashion Figure

An illustration done to promote a garment is in close competition with its competitor—the photograph. The last thing you would want to do is to mimic a photographic image. Instead, do exactly the opposite: Fly in the face of convention. Do what a camera is unable to do, adding verve and a sense of abandon to the illustration.

This is a simple pose, but I selected it because the very act of showing a position facing totally away from the viewer is arresting. Little was added to the figure outside of directing attention to the powerful stance.

Folding the arms out of sight shifts attention to the legs.

Strong, black, wet marker lines are used to emphasize diagonals.

The leg spread looks normal, but I exaggerated the stance by placing the legs a little apart where they join the trunk—something a photographer couldn't do.

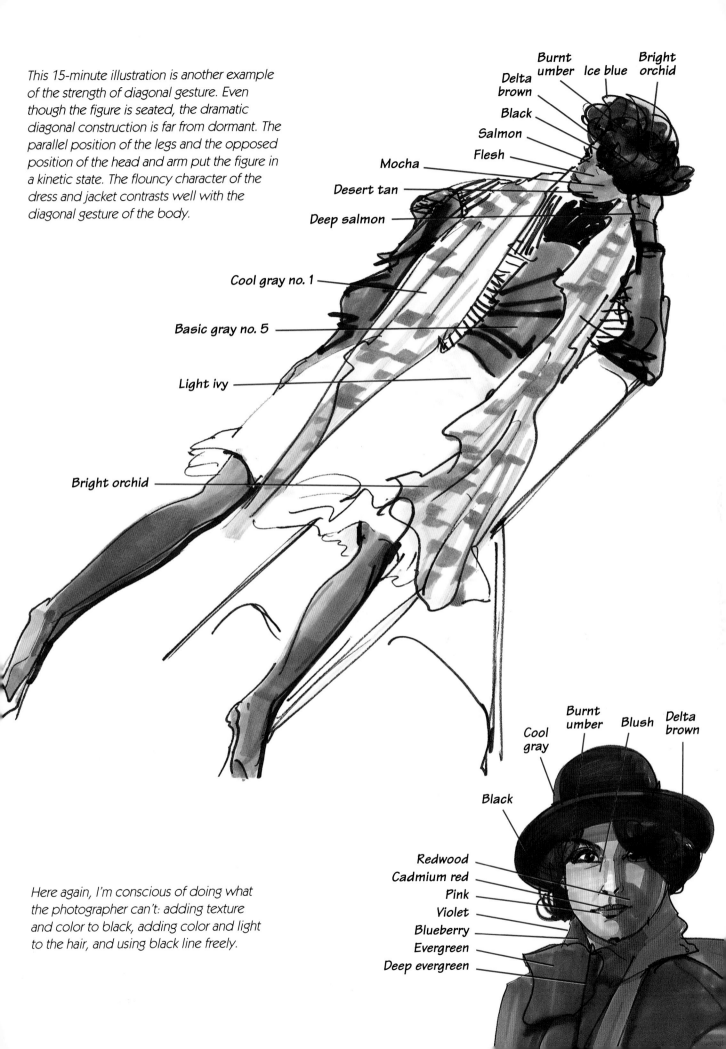

This 15-minute illustration is another example of the strength of diagonal gesture. Even though the figure is seated, the dramatic diagonal construction is far from dormant. The parallel position of the legs and the opposed position of the head and arm put the figure in a kinetic state. The flouncy character of the dress and jacket contrasts well with the diagonal gesture of the body.

Burnt umber
Ice blue
Bright orchid
Delta brown
Black
Salmon
Flesh
Mocha
Desert tan
Deep salmon

Cool gray no. 1

Basic gray no. 5

Light ivy

Bright orchid

Here again, I'm conscious of doing what the photographer can't: adding texture and color to black, adding color and light to the hair, and using black line freely.

Burnt umber
Blush
Delta brown
Cool gray
Black
Redwood
Cadmium red
Pink
Violet
Blueberry
Evergreen
Deep evergreen

The Model

I use models often in my work—principally myself! Using a good Polaroid 600SE camera and a light stand, I can pose in a variety of positions, releasing the shutter through a long extension. The mirror is also of great value, and I sometimes carry a small one in my pocket, particularly for studying facial expressions.

Asking friends to volunteer as models is an easy way to get the action right, and usually they're glad to help. But draw frequently from people in action, making the natural gestures of everyday life—sitting, jogging, playing basketball, whatever. This is a wonderful way to understand the figure and acquire a loose, free style.

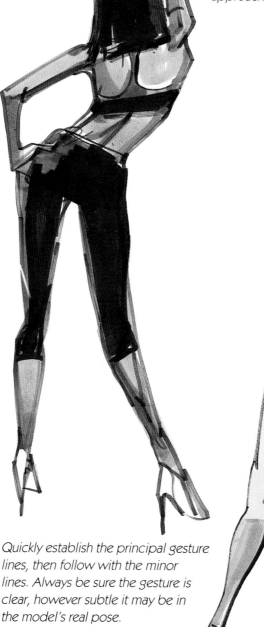

This is a good way to use line—big and flashy— either wet or dry. A Design Marker 229LF is a good tool for this.

Use a lot of black, both in line and mass. Black represents real visual power, so don't be afraid to use it boldly. The pose is thrown way out of line, but that doesn't matter: Don't be timid about overstating the gesture. This attitude should carry over into your approach to all figure drawing.

Quickly establish the principal gesture lines, then follow with the minor lines. Always be sure the gesture is clear, however subtle it may be in the model's real pose.

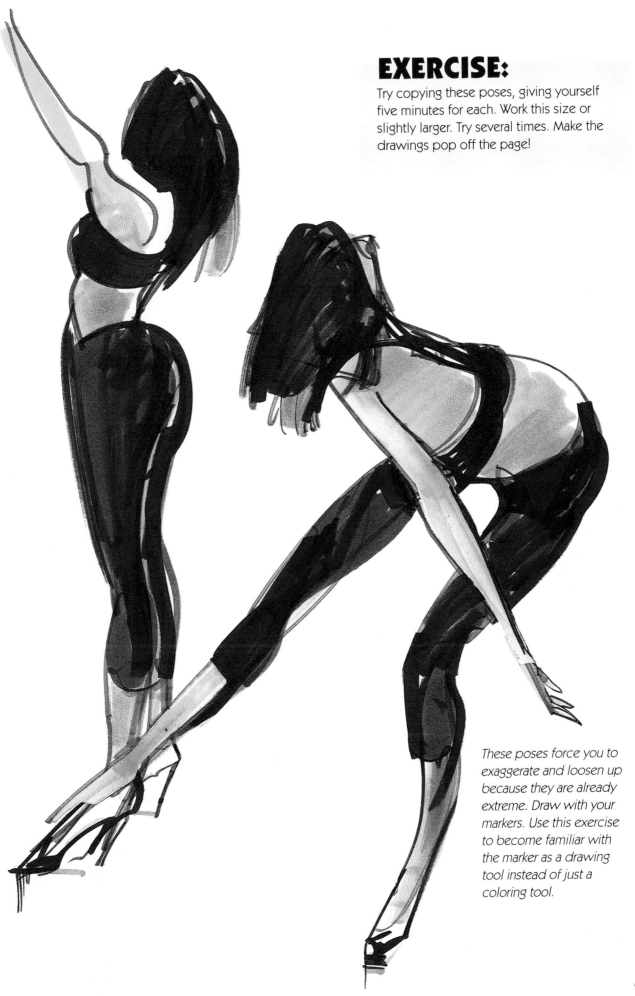

EXERCISE:

Try copying these poses, giving yourself five minutes for each. Work this size or slightly larger. Try several times. Make the drawings pop off the page!

These poses force you to exaggerate and loosen up because they are already extreme. Draw with your markers. Use this exercise to become familiar with the marker as a drawing tool instead of just a coloring tool.

ROMANCING THE SKIN

The most versatile and satisfying surface you'll ever paint is flesh. You may sometimes choose "flesh" color for speed and convenience only, but it doesn't even begin to convey the incredible subtlety and beauty of human skin. When you contemplate the figure in terms of color and light, you will feel challenged—and motivated to attempt to express its beauty on paper.

Markers have a good range for painting skin colors. You also have great latitude to explore new color approaches that go way beyond the normal academic approaches.

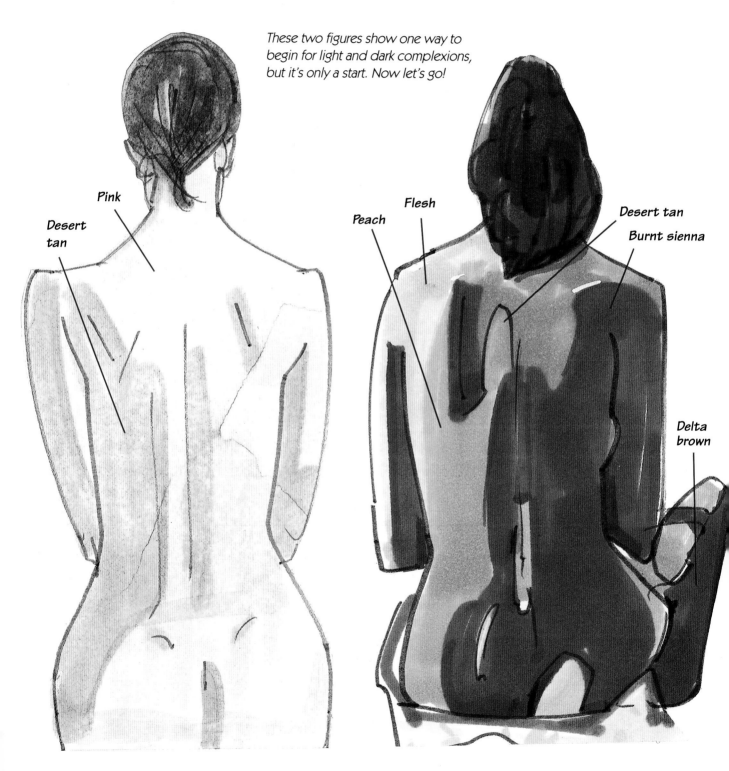

These two figures show one way to begin for light and dark complexions, but it's only a start. Now let's go!

Desert tan

Pink

Peach

Flesh

Desert tan

Burnt sienna

Delta brown

Skin doesn't usually come in a single color, but sometimes it's convenient and convincing to treat it that way. Actually, this male figure runs from pink at the top through warmer colors to darker colors at the bottom. The face often has more color because it's exposed to the weather. The feet of a light-skinned person are always on the pink side because they are usually protected from sun and wind.

The beauty of human skin is that it's always different—within every figure and from one person to another. Start with a believable color scheme, and then paint the skin so that it's alive and moving.

Chest and trunk are often in the pale sepia, cream, Naples yellow, sepia range.

Now the legs begin to take on a pinkish color again, especially in the knees and feet. Lower legs are usually darker in a standing position because they catch the least light. Feet are basically horizontal, so the tops pick up as much light as the shoulders.

Use a blender to pull these disparate colors together, or try a subtle skin tone, like pale flesh.

Now throw the lower limbs into a darker color—suntan—in order to add luster to the value combinations from head to foot.

The Range of Skin Color

Dark skin can range from pale flesh or mauve to delta brown. Light skin has just as great a range. Not every job permits this much exploration, but when it does, take advantage of it.

A good way to blend skin tone is to use a lighter color or blender to soften edges. Don't be afraid to apply dark and light colors alternately in order to blend edges. Also, laying down a second coat on top of a color after it dries will increase the value. Use line to hold edges and to indicate features.

Notice the difference in line width, and also take advantage of the variety in line strength available to you. You can use line occasionally to outline value changes. Work in line to a certain point, then switch to color. Go back and forth between line and color until the result pleases you.

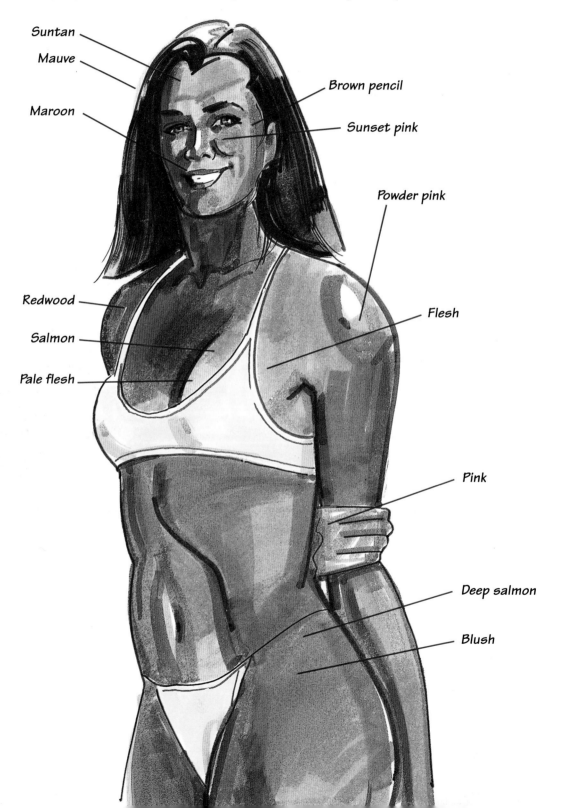

Suntan

Mauve

Maroon

Brown pencil

Sunset pink

Powder pink

Redwood

Salmon

Pale flesh

Flesh

Pink

Deep salmon

Blush

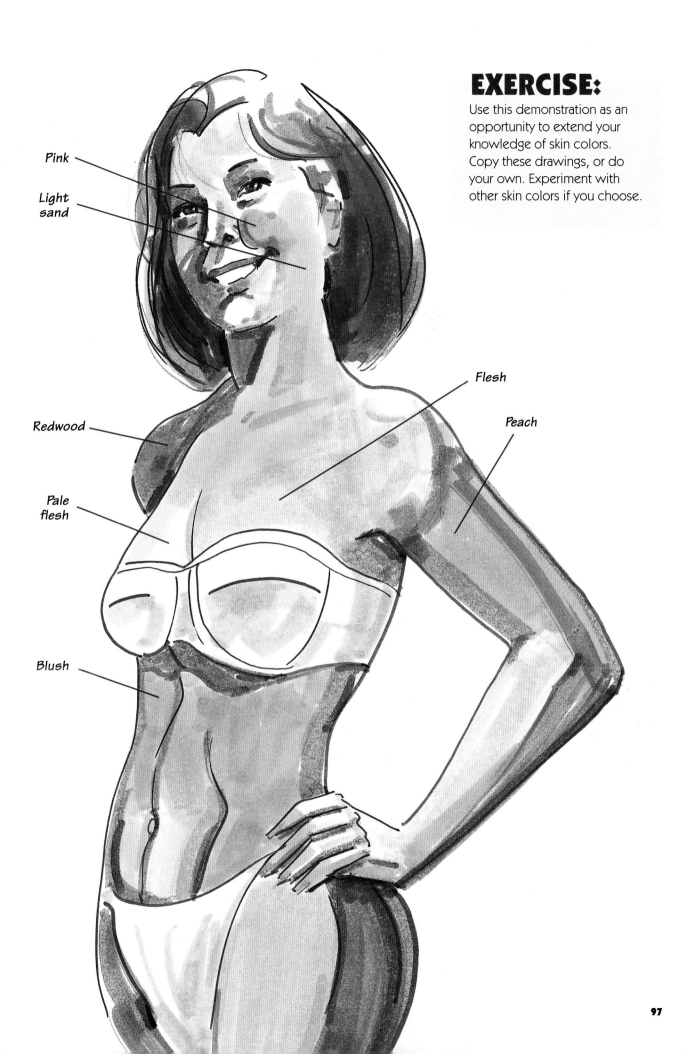

Pink

Light
sand

Redwood

Pale
flesh

Blush

EXERCISE:

Use this demonstration as an
opportunity to extend your
knowledge of skin colors.
Copy these drawings, or do
your own. Experiment with
other skin colors if you choose.

Flesh

Peach

Learning to Look at Skin

There's a great variety in skin colors. Even within a single figure, color can vary from the lightest pink to the darkest brown. Both direct and reflected light also contribute to make flesh richer and more varied. Flesh seen in flat light is totally different than when seen in bright sun, or when reflecting any kind of light, artificial or natural.

 The mind will accept almost any color combination if the figure is well drawn, or is even loosely drawn and handled with some intriguing color combinations. These ethnic examples are not the national average. They succeed because they exaggerate, and because they please.

"Yellow" skin: light ivy, kraft brown, mocha, flesh, and delta brown.

Brown skin: suntan or pale sepia for the lights, pale olive and olive for the darks. This type of skin goes gracefully toward green, especially in the darks.

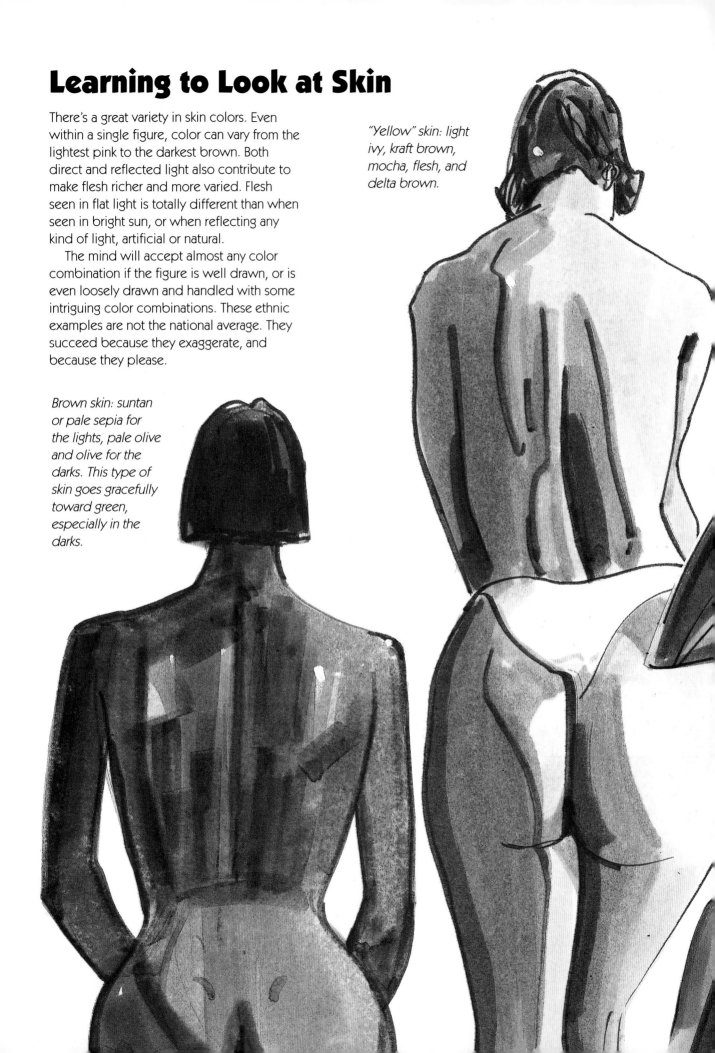

EXERCISE:

Study these exotic colors and have fun copying them. Experiment with your own combinations, but these suggestions are plenty to get you exploring skin colors. Start with the bold colors first. Then you're sure of making a powerful statement!

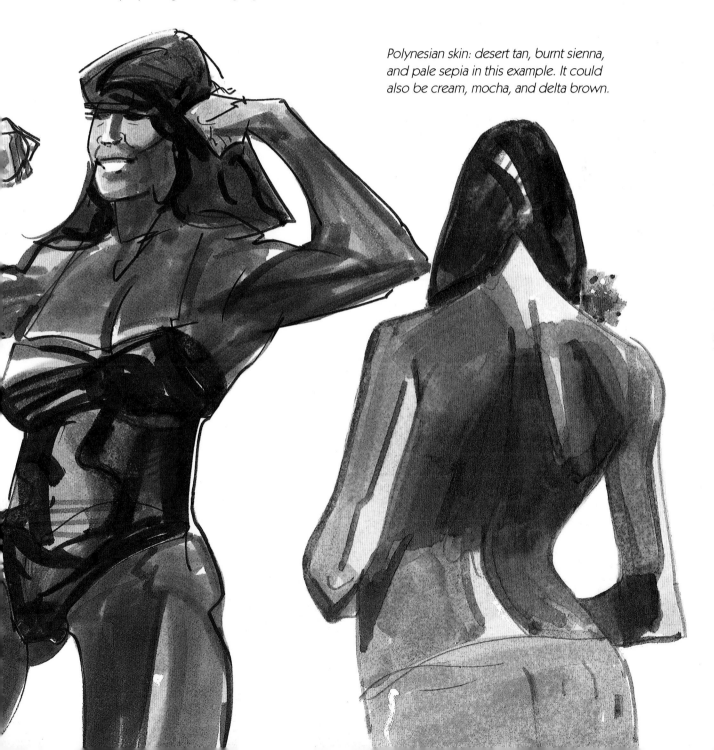

Dark skin: delta brown and pale sepia, with mauve and purple sage in the highlights.

Polynesian skin: desert tan, burnt sienna, and pale sepia in this example. It could also be cream, mocha, and delta brown.

FOLDS AND WRINKLES IN CLOTHING

When you are painting clothing, keep the folds and wrinkles simple. Limit stress pulls, and be sure to leave plenty of clean, open fabric. Otherwise many garments become a nightmare of tangled cloth.

A good way of handling wrinkles is to throw areas into shadow instead of rendering every wrinkle. The face, for example, needs very few lines to explain its form. In clothing I get a lot of mileage from blending the shadow edge. It softens the figure and plays well against the hard-edged outline.

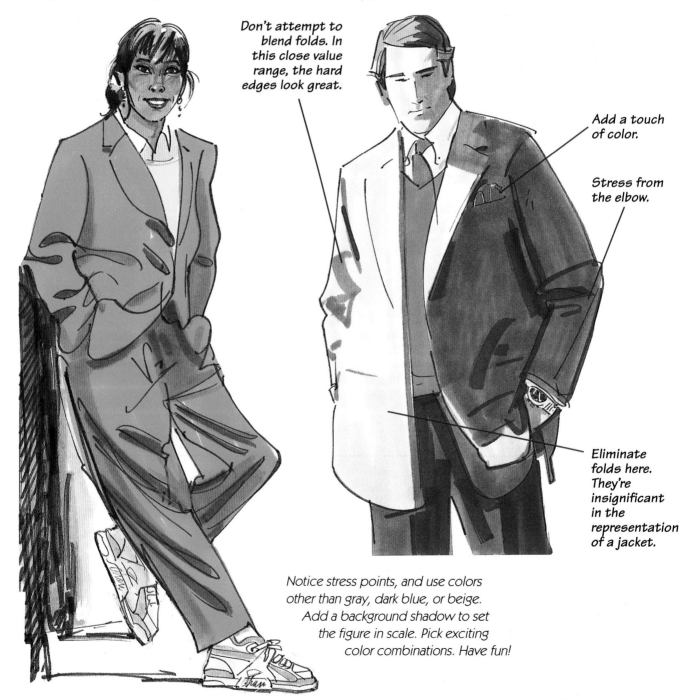

Don't attempt to blend folds. In this close value range, the hard edges look great.

Add a touch of color.

Stress from the elbow.

Eliminate folds here. They're insignificant in the representation of a jacket.

Notice stress points, and use colors other than gray, dark blue, or beige. Add a background shadow to set the figure in scale. Pick exciting color combinations. Have fun!

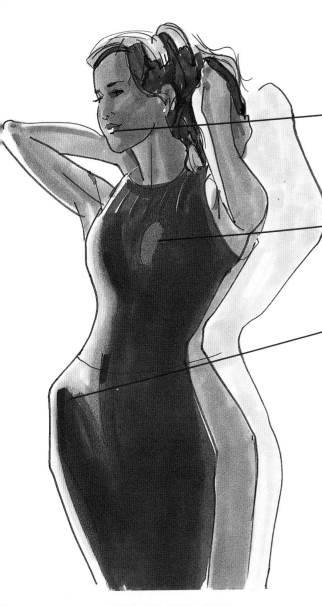

Accent the face with a highlight.

Pick up a soft light here.

Accent the figure with a strong shadow.

Use colored pencil to get the feeling of fur.

Never render wrinkles; only suggest them by indicating the direction of the pull. Fabric reacts to stress by pulling or by bunching up. Use as few lines as possible to convey this, and contrast wrinkled fabric with smooth, unstressed fabric.

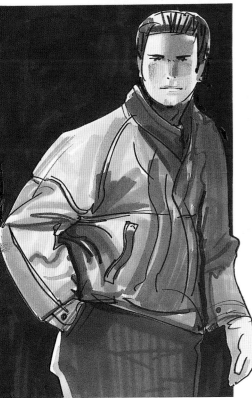

Leather is soft and round. Use a flesh underlay and "rounded" wrinkles. But be frugal. Use as few lines as possible. Shadows are redwood with delta brown as an accent.

FOOD: CONVEY THE SIZZLE, NOT THE STEAK

It's an advertising cliché, but it applies well to the illustrator. Our purpose is not to duplicate nature, but to invent our own ways to add interest and create desire. Always begin with something real, but add excitement. Take full advantage of highlights, color, wetness, accents, and shadows that may be understated in nature, and use them to make the food look as mouth-watering as possible. Remember, you have much more control over this than the photographer or the retoucher.

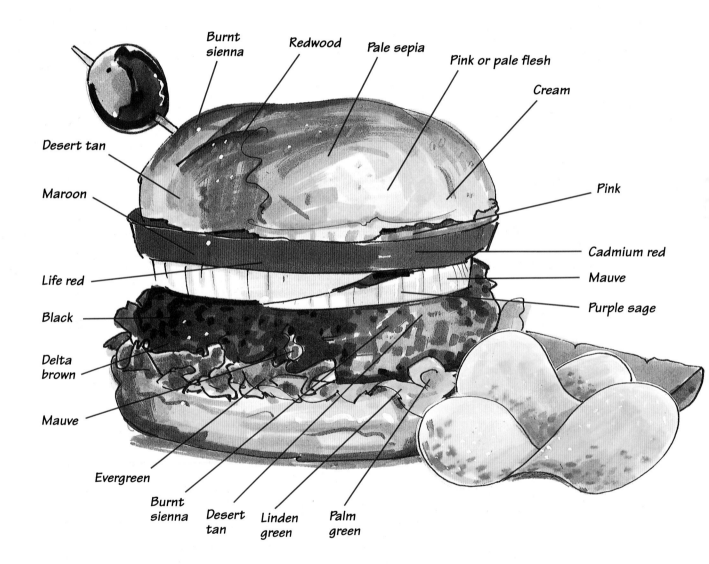

Begin by breaking down the food into its parts. The hamburger is a top bun, tomato slice, onion, ground beef, lettuce, and bottom bun. Then each part has a light and dark side and a light or dark accent.

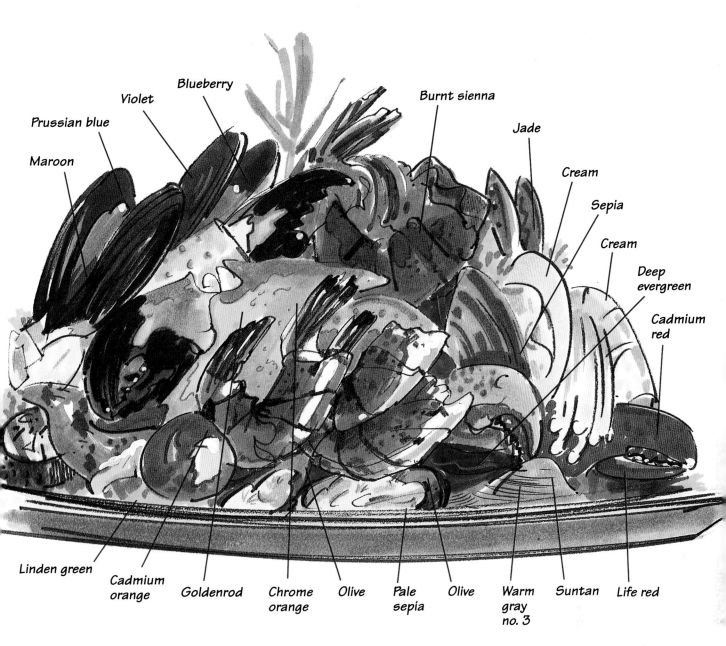

Prussian blue

Maroon

Violet

Blueberry

Burnt sienna

Jade

Cream

Sepia

Cream

Deep evergreen

Cadmium red

Linden green

Cadmium orange

Goldenrod

Chrome orange

Olive

Pale sepia

Olive

Warm gray no. 3

Suntan

Life red

Any food should always be placed against a high-contrast background or a strong color that makes it look appetizing. I used black here, but white would work as well, or cadmium red, or many other colors.

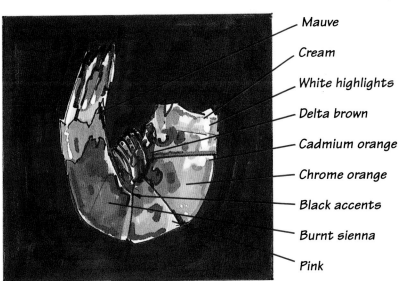

Mauve

Cream

White highlights

Delta brown

Cadmium orange

Chrome orange

Black accents

Burnt sienna

Pink

103

PRODUCTS

Drawing various products represents a large part of the illustrator's work. As with any other type of illustration, practice makes perfect. If you are drawing wrenches, for example, your 300th illustration will work great, while the first dozen are more apt to be unimpressive. Concentrate on the simple principles described here that will make any product you draw sparkle.

Here are some common products that have many of the characteristics of more complex ones: straight lines, curved lines, complex geometrical surface textures, perspective, highlights, color, shadow. All the drawings share these features, although they may differ slightly.

Draw the product using a minimum of lines, but try to capture its character. Next add shadow, being careful to place the darkest value at the edge where shadow and light meet. Then let the shadow fall off as it continues along the surface upon which it rests. Even if the handle is a cylinder, it still has a darker turning edge as it goes into shadow.

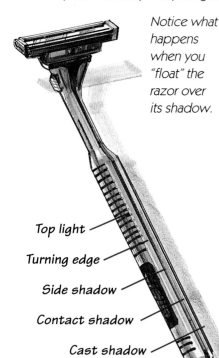

Notice what happens when you "float" the razor over its shadow.

Top light

Turning edge

Side shadow

Contact shadow

Cast shadow

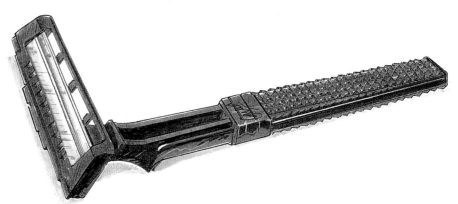

Light and shadow make this razor pop, more than color or the manner in which it's drawn. Be certain the shadow side is much darker than the light side.

Now try a toothbrush using a cast shadow.

Modify the shadow, picking up colors reflected from the transparent handle.

Always feel free to add extra elements to lend interest to the product: toothpaste, running water, hand.

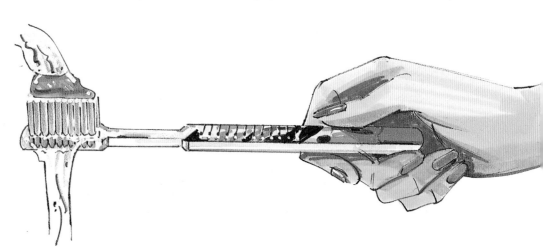

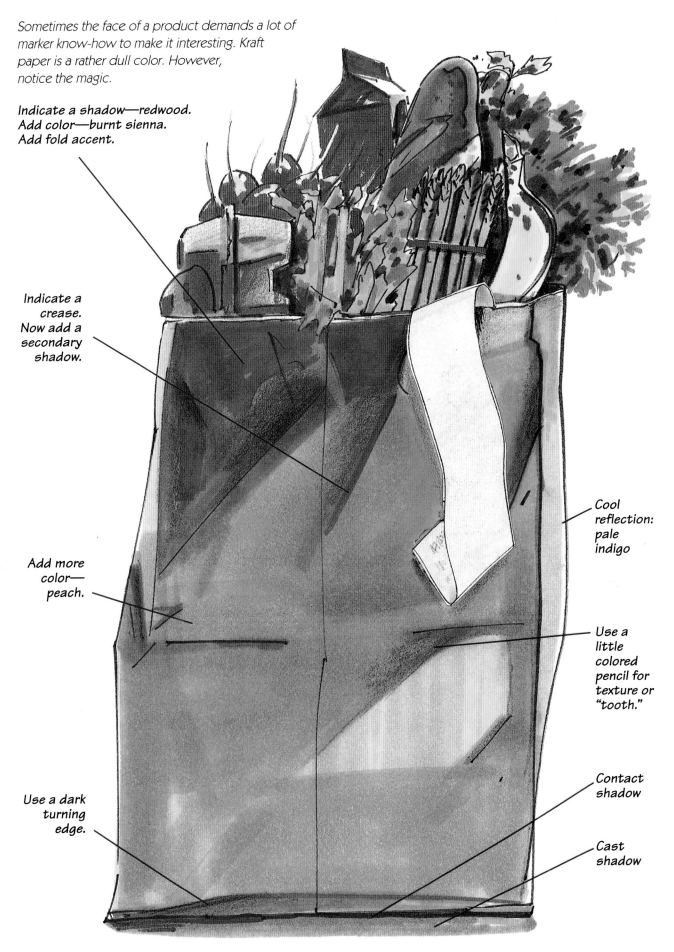

Sometimes the face of a product demands a lot of marker know-how to make it interesting. Kraft paper is a rather dull color. However, notice the magic.

**Indicate a shadow—redwood.
Add color—burnt sienna.
Add fold accent.**

Indicate a crease. Now add a secondary shadow.

Add more color— peach.

Use a dark turning edge.

Cool reflection: pale indigo

Use a little colored pencil for texture or "tooth."

Contact shadow

Cast shadow

CARS

After many years of drawing cars, I still think of them as two boxes, one on top of the other, with one side shadowed and a dark shadow beneath. That much at least still hasn't changed. Another important characteristic of cars is their reflective quality. They reflect everything—sky, clouds, trees, buildings, roads—not only in their windows but in metal on all sides, in hubcaps, even on tire treads.

It's important to take advantage of this reflective quality. Play it to the hilt. Cars appear often in illustration, so get used to them—and love them.

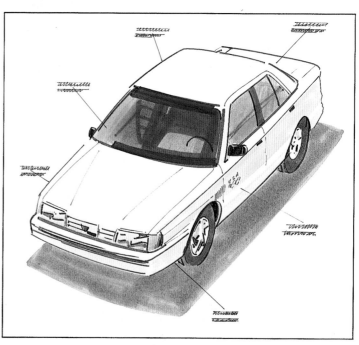

A good way to begin illustrating cars is by doing quick drawings. Get the look or character of the car in your head. This illustration at right took seven minutes to complete.

The car below took 2 to 2½ hours. The background was painted but could have been done separately and the car pasted in on top. I was careful to get blended or graded edges against the more opaque areas. It was also important to get the dark and light accents clear.

I wiped the windshield with pink and purple sage, blending it but with the pink dominating. The grille and tire on the right were first indicated, then eventually taken totally out with black, in the interest of simplifying the car.

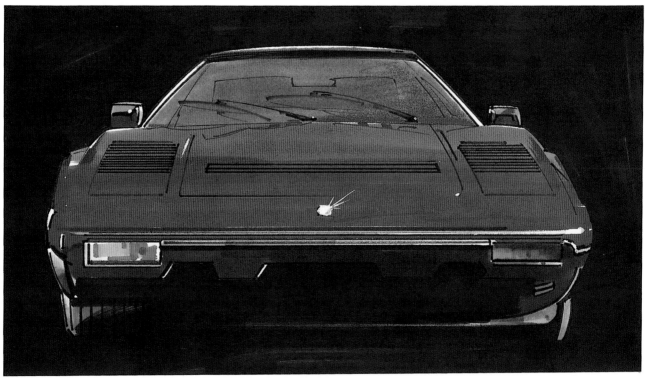

Tires are monochromatic, with a highlight indicated on the top planes using a light-gray colored pencil.

Simple hubcaps are a reflection of sky on top and ground on the lower half, with horizon in the middle, greatly simplified.

The chassis is similar, reflecting light at the top, road at the bottom. The horizon is usually reflected just below the center.

This Corvette pulled up behind me at the gas station, and I wasted no time shooting it with my old Leica, along with the passenger. I took the character from the back of his shirt and positioned it on the front. The combination made lively subject matter.

The drawing was done by "eyeballing" the photo of the car and adding the passenger and T-shirt. I added an arbitrary shadow of the cab to the hood and changed the color of the tires from cool to warm.

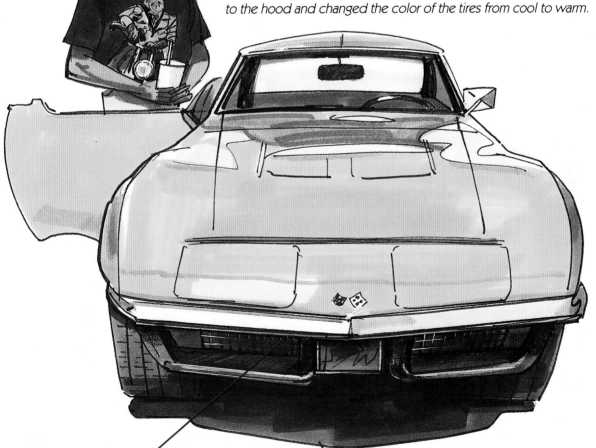

The grille was thrown into shadow to set off the car.

I decided to make the shadow green, not black, to get a better combination with the yellow.

MOVEMENT

The natural marker stroke can be used to suggest motion in a different approach to application methods. Using a diagonally parallel stroke following the action of the subject, we can assist the impression of movement. This can be employed both within the subject and without. Look at the following example and see how effective this is.

Working on tracing paper with a blender is a good way to imply motion. In this example I painted a coat of life red and followed by streaking it with a blender, wiping it clean after each stroke. The diagonals always lend a feeling of movement. The short strokes at the bottom suggest a less active mood.

EXERCISE:

Familiarize yourself with this technique. It's easy; all you need is a blender. Try it several times, and then cement an illustration over the most successful result. Pick a subject where you want to convey motion.

Here I applied burnt sienna diagonally near the ground, as a glaze over buff. In this approach, I intentionally left some white to add sparkle and swiftness to the style. Longer streaks of dark brown pencil reinforce the direction of the action.

Speed

There are many ways to suggest a rapidly moving vehicle. A soft or blurred background is a common technique, and Denril vellum is an excellent paper for such special effects.

Throwing the rear into soft focus and blueing it are also common. "Speed lines" still work; there are many ways of doing them. Captions help too: "At 120 miles per hour this car hardly moves." Even though the car is in perfect focus, you believe that it's speeding.

For this illustration I made the background stand still in contrast to the fast-moving train. Fading values and lines in the train, as well as perspective lines, suggest speed.

This out-of-focus area is the only color streaked in the background. To do this, I used rubber cement solvent and a cotton swab.

The mountain edge was achieved by turning the paper upside down and painting the edge with solvent and a cotton swab over deep evergreen.

This mysterious edge was blotted by a straightedge and left as a happy accident.

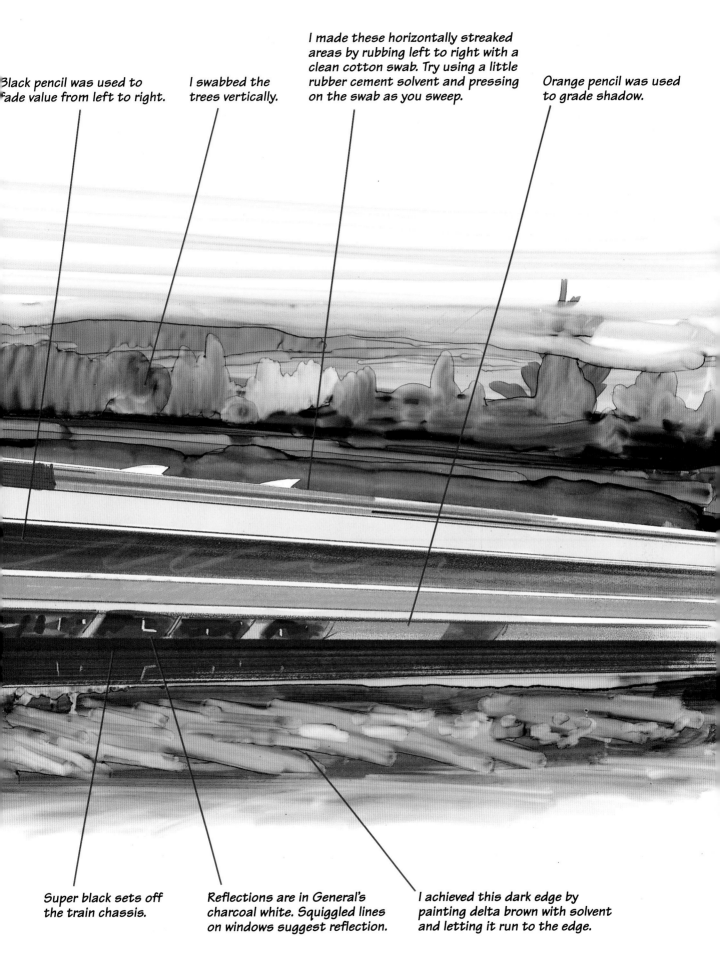

I made these horizontally streaked areas by rubbing left to right with a clean cotton swab. Try using a little rubber cement solvent and pressing on the swab as you sweep.

Black pencil was used to fade value from left to right.

I swabbed the trees vertically.

Orange pencil was used to grade shadow.

Super black sets off the train chassis.

Reflections are in General's charcoal white. Squiggled lines on windows suggest reflection.

I achieved this dark edge by painting delta brown with solvent and letting it run to the edge.

SHINY CYLINDERS

The enigmatic reflective cylinder appears often to challenge our expertise. Lipstick, chrome chairs, motorcycles, pens, tractor trailers, razor handles— a plethora of everyday things all have these features in common.

Memorize this formula and every cylinder you'll ever paint will be the same, with minor local variations. But remember, don't copy slavishly. Use your own judgment in making color decisions.

Most important are a dark center, an edge light, and a crisp pen line defining the edges. Various minor reflections appear on one side only.

Warm is reflected on one side.

Cool is reflected on the other side.

A dark line separates the light side from the shadow side.

Introduce a variety of local color. Study the metal. Gold, silver, and chrome cylinders reflect color identically.

In the middle of the cylinder are medium-value colors, reflecting various local colors. A dark line outlines the local colors.

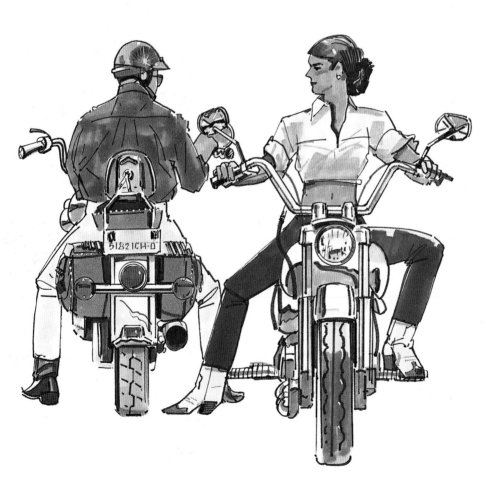

With these bikes I decided to make the surfaces facing downward reflect warmth; those facing the sky are cool.

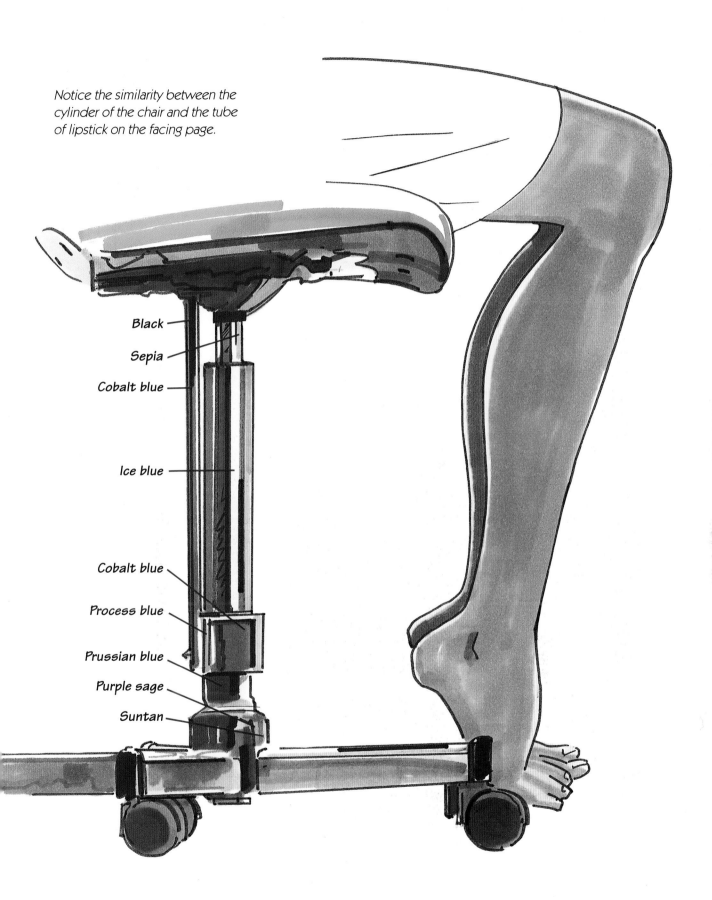

Notice the similarity between the cylinder of the chair and the tube of lipstick on the facing page.

Black

Sepia

Cobalt blue

Ice blue

Cobalt blue

Process blue

Prussian blue

Purple sage

Suntan

WATER

Water displays such a variety of faces that it would be difficult to do justice to all the many different possibilities. To render it convincingly, it's important to understand how water works. Here is one conventional use that you're likely to encounter:

ocean water. Large bodies of water reflect sky color and bottom color. When placid, they also reflect all surrounding objects. The same is also true for bubbles, puddles, and ice. Keep that in mind as a basis for indicating all water.

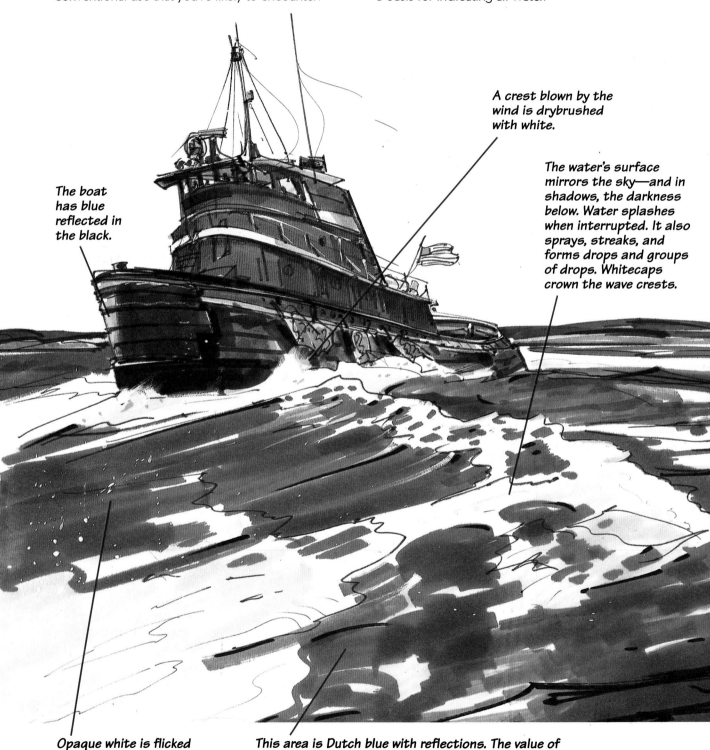

A crest blown by the wind is drybrushed with white.

The water's surface mirrors the sky—and in shadows, the darkness below. Water splashes when interrupted. It also sprays, streaks, and forms drops and groups of drops. Whitecaps crown the wave crests.

The boat has blue reflected in the black.

Opaque white is flicked from the brush.

This area is Dutch blue with reflections. The value of the water should be different from that of the boat.

Car reflections are particularly erratic because there are other reflections interfering. That makes it easier to add additional color. Give yourself license to exaggerate color streaks.

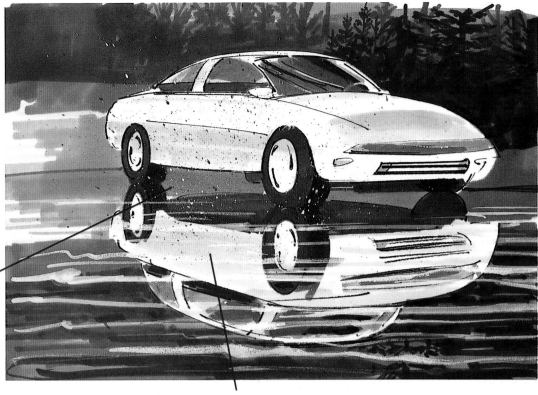

Both dark and light flecked from brush. Dark represents backlit drops.

The car's reflection is often a slightly darker value than the original. There are also highlights and darks reflected. Rembrandt used calligraphy like this in his landscape sketches to express the undulating and irregular character of road shadow and arbitrary reflections of sky.

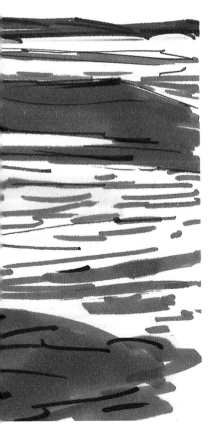

Water picks up color as it moves.

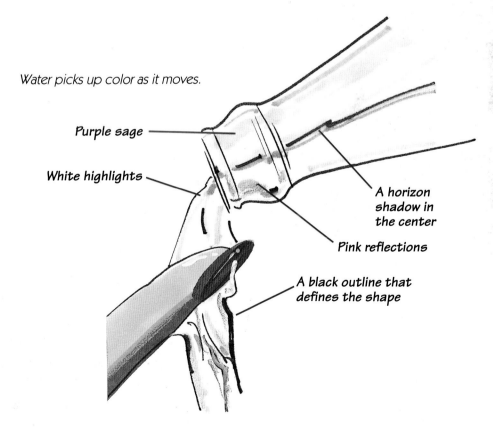

Purple sage

White highlights

A horizon shadow in the center

Pink reflections

A black outline that defines the shape

FLUIDS AND GLASS

The character of a fluid is always erratic and unpredictable, but keep a light source. Liquid is no different from a box, just more fluid. I always kick around color and squiggles with impunity, and it works.

Here is a typical wine glass with some of the wild flashes of color that dash about the liquid and sides. This illustration was done on Bienfang 340 paper. Always test colors before using them. You want to push red in all directions from pink to black.

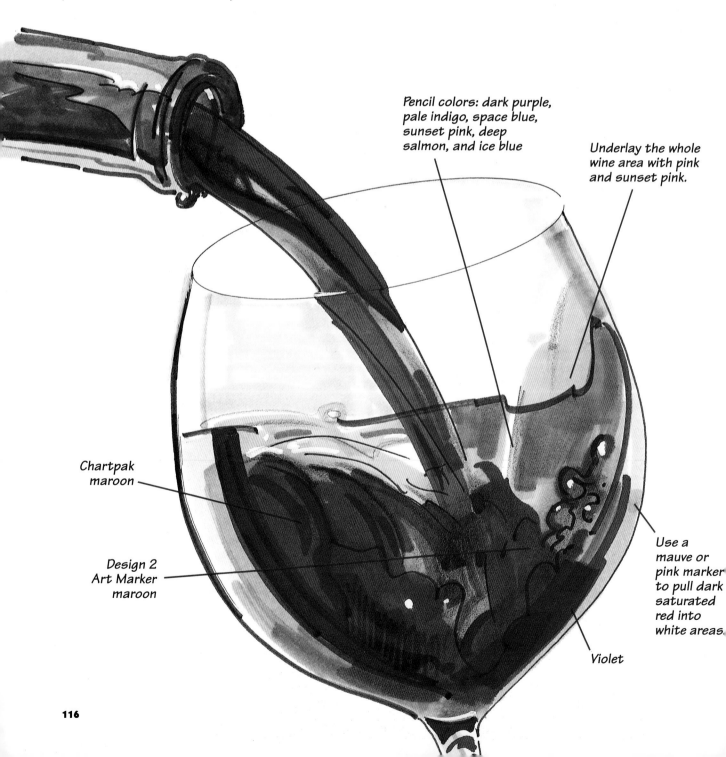

Pencil colors: dark purple, pale indigo, space blue, sunset pink, deep salmon, and ice blue

Underlay the whole wine area with pink and sunset pink.

Chartpak maroon

Design 2 Art Marker maroon

Use a mauve or pink marker to pull dark saturated red into white areas.

Violet

Beer does wonderful things to a glass, particularly thick glass. Notice how the color races around the base. The basic color of glass becomes lemon yellow, then changes into goldenrod, chrome orange, cadmium orange, burnt sienna, pale sepia, delta brown, and black. Glass often picks up sky blue or even cobalt blue from light sources.

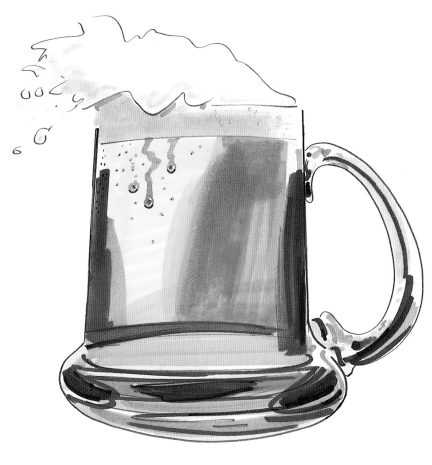

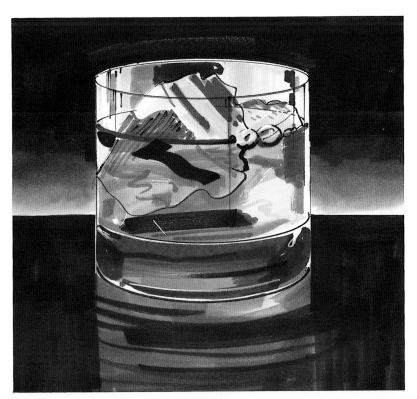

Black is commonly used as a background color in illustrations of beverages. It adds great contrast to colors and pops the whites. It also reflects, or echoes colors in the liquid.

WOOD

Don't take wood too seriously; you can make it look quite realistic without rendering every single detail of the grain pattern. Color should drift slightly from side to side as you pass along the plane of the wooden surface. It's a good idea to study the color and grain of various woods because there is great variety. Oak, for example, is cream and desert tan. Cherry is pretty close to redwood. Pine can be pale yellow or pale sepia. Finishing can add color and luster.

Outline dark areas with brown Pentel pen.

Use black outline pen for punch.

The edge is both lighter and darker than the top surface as it goes from left to right.

To render this mahogany panel, I used a light undercoat of burnt sienna and varied the pressure going from left to right. While it's still wet, add diagonal strokes of the same color.

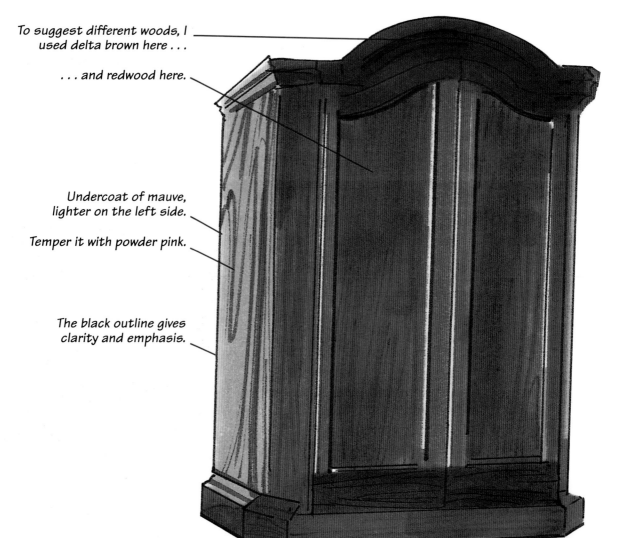

To suggest different woods, I used delta brown here . . .

. . . and redwood here.

Undercoat of mauve, lighter on the left side.

Temper it with powder pink.

The black outline gives clarity and emphasis.

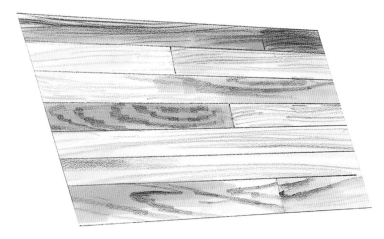

Oak floors display a variety of colors depending on their cut. Combine lighter colors and colored pencil for grain. Use a brown Pentel to separate boards, and be sure each board is different in either color or grain.

Grain is burnt sienna and redwood.

Underpainting is pale cherry with flesh highlights.

Mauve pencil

End grain is black and delta brown, graded.

Yellow pencil edge

Burnt sienna or redwood

Underpainting: pale cherry with peach glaze

Grain: redwood, using thin edge of nib

Add shadows for interest.

LANDSCAPES

Landscapes can be beautiful, but at the same time too involved and complicated for marker work. If you need to be as meticulous as Frederic Church, for example, you would certainly pick a different medium.

But since the marker artist's work is often needed quickly, you must take a simpler approach. Sand, sea, trees, rocks—all must be reduced to a recognizable form designed for speed and spontaneity. Fortunately, markers are well up to the task.

Every comp artist must devise a method for suggesting objects. Trees are clumps of leaves, with the light usually striking from above and shadow showing beneath. Trunks are treated in the same way. Of significant importance, both must cast a shadow on the earth. Showing sky through the tree is very important as well. Every element of the picture must be simplified in the same manner.

Rocks react the same to light and show a cool upper surface and a warm shadow—or, if you prefer, the opposite. But they also throw a shadow on any adjacent surface.

When rendering skies, pick a violet light, ice blue, and space blue and hold them in your nondrawing hand uncapped. In your drawing hand, hold a pale indigo. Now use them very wet, beginning with the lighter values, since they prevent darker colors from drying with a hard edge. Go for soft, interesting, cloudlike shapes with the darker colors at the top. Add a little process blue for distant sky color. If it succeeds, continue the illustration. If the finished piece is unsuccessful, combine the other portion of the illustration by replacing it with a new sky area. Simply use rubber cement to attach it into the right position. This patching technique will be discussed in the section on invisible patching on page 142.

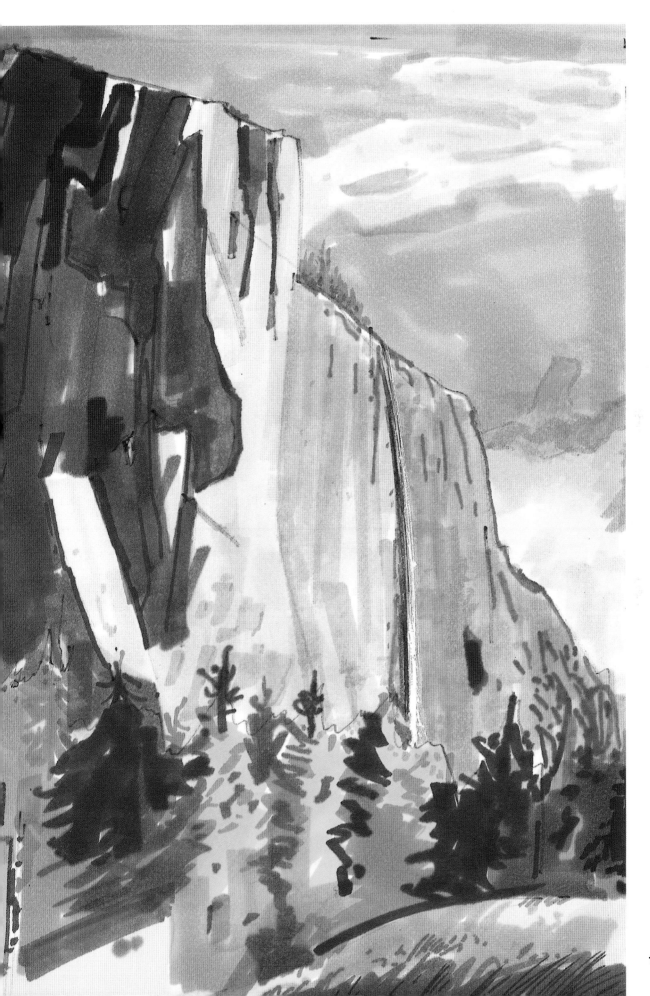

Shadow

As objects recede, they lose red and appear bluer. They also lose value and detail; edges go soft. Even a single shadow can run through these transitions. If it's the only shadow in the illustration, I try to give it as much variety from front to back as I can.

Space blue: The most distant shadow is the bluest, the lightest, the softest, and the simplest.

Dutch blue: As the shadow goes to the middle ground, it becomes bluer and lighter.

Prussian blue, the reddest and darkest shadow

Light patterns within the shadows are roughly elliptical.

Figures have a shadow side but pick up other shadows as well, from extended arms or from another object throwing a shadow on them. In addition, their shadow will fall on whatever is in its path.

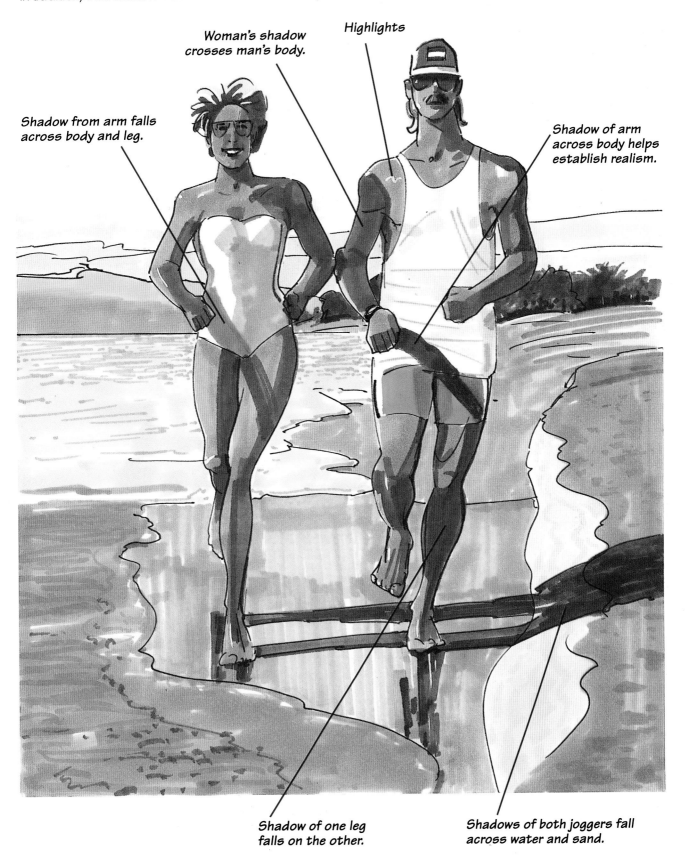

Woman's shadow crosses man's body.

Highlights

Shadow from arm falls across body and leg.

Shadow of arm across body helps establish realism.

Shadow of one leg falls on the other.

Shadows of both joggers fall across water and sand.

Weather

Here are a few simple tricks to indicate rain, snow, and wind. First of all, use no more than four colors to pin down the effect. The simpler the indication, the more powerful the picture. In place of millions of raindrops, for example, it's better to indicate a large, dark sky with only a few drops. This suggests the very beginning of the storm, with an imminent deluge. It's also much faster to paint.

Snow always has some flakes that block, rather than reflect, the light. The same is true for raindrops: Some of them catch the light, while others don't and go dark.

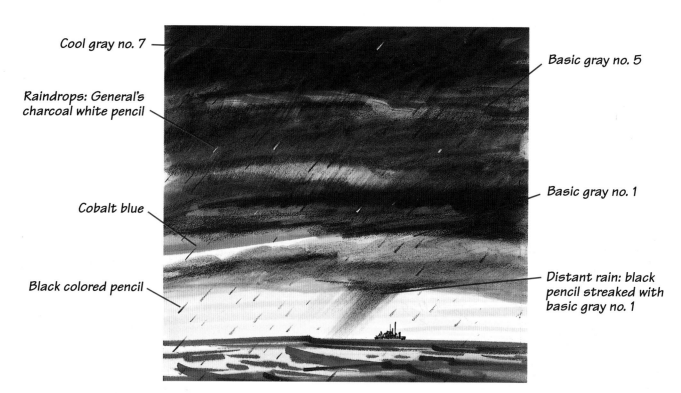

Cool gray no. 7

Raindrops: General's charcoal white pencil

Cobalt blue

Black colored pencil

Basic gray no. 5

Basic gray no. 1

Distant rain: black pencil streaked with basic gray no. 1

EXERCISE:

Try painting a rainstorm and a snowstorm yourself, based on these compositions or others of your own choosing. See how quickly you can achieve these effects.

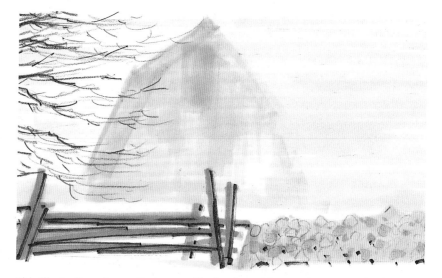

This illustration shows that many kinds of weather—rain, snow, fog, haze—reduce visibility and neutralize values, especially as objects recede into the distance. Here I worked on Bienfang 360 paper and indicated the middle ground with cool gray no. 2 and pale indigo.

Snow can easily be indicated by using three colors: "white" paper, space blue, and ice blue. In this illustration there are three blues: sky blue for the water below and the sweep of distant shadow, space blue for the cast shadow behind the buildings, and cobalt blue for the river bank.

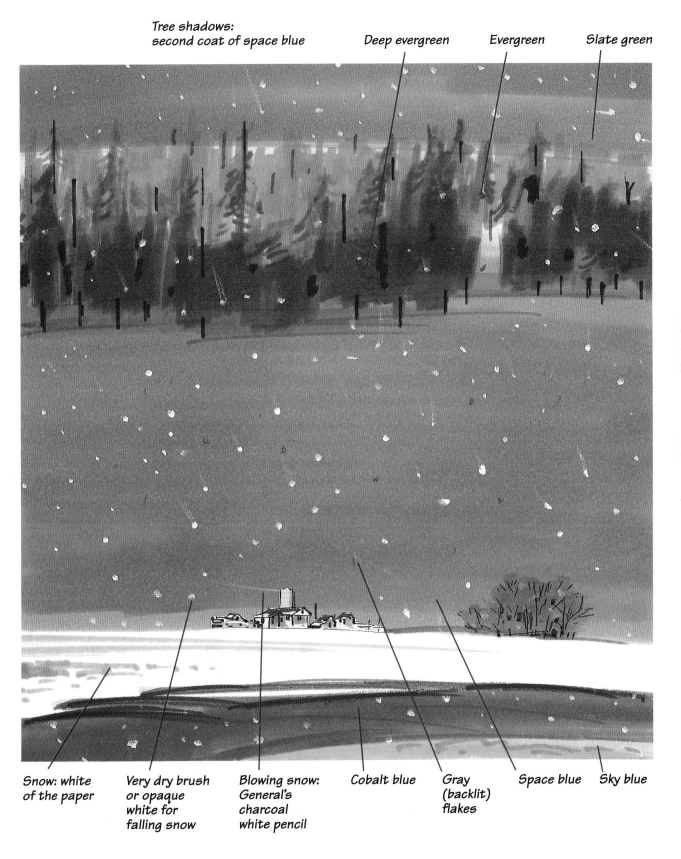

Tree shadows:
second coat of space blue

Deep evergreen

Evergreen

Slate green

Snow: white
of the paper

Very dry brush
or opaque
white for
falling snow

Blowing snow:
General's
charcoal
white pencil

Cobalt blue

Gray
(backlit)
flakes

Space blue

Sky blue

Ambient Light

Ambient light, or the ever-changing light that surrounds us at all times, is an important source of information for the illustrator. It floods the picture with color and can suggest the time of day. Here are the principal daily light conditions and how you can suggest them with your marker palette.

Sunrise lasts only an instant and is yellowish with long, cool, thin shadows. Here the hikers' face shadows are redwood and their light sides are cream. The sky contains ultramarine, sky blue, cream, and pink.

Noon brings strong overhead light and ultramarine or cobalt blue skies. Clouds are white with maize or warm gray no. 1 shadows. Faces' shadows remain redwood, with suntan and flesh tones on their lighter sides. The sky is ultramarine blue or cobalt blue, with Pantone 263 or warm gray no. 1 for backlit clouds.

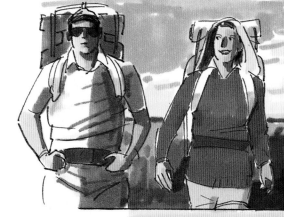

At sunset the light goes toward chrome orange, bathing everything in warm colors with long, dark, purplish shadows. The faces' shadows still remain redwood, but the light sides have become flesh with a cream overlay. This sky contains sky blue, pink, maize, pale olive, purple sage, and ice blue.

Dusk means extraordinary sky effects, with the sky appearing very bright against a dark foreground and horizon. The faces are now redwood and delta brown. The sky is cadmium orange in some places and in other places contains two coats of chrome orange.

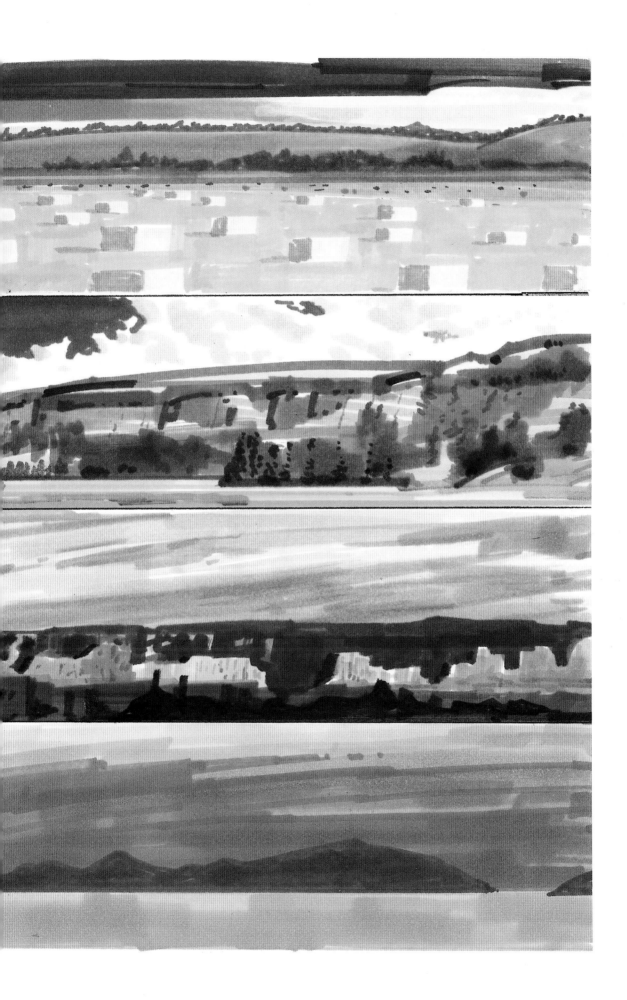

Night

Nighttime scenes in film can be shot "day for night" by shooting during the day using strong shadows and a density filter, which prints dark. The result looks as if it had been shot at night. You can do the same thing by adding blue, heavy shadows, and low-key color. You can actually render your illustration normally and add, say, a space blue overall glaze. Simply leave highlights of "moon color" to suggest night.

Foreground subjects at night can still have detail, but will be bluer (space blue) or greener (olive, dark olive) depending on which you choose, and closer in values. Work with a palette limited to colors in the blue or green range, or add a wash of medium value.

I occasionally use night lighting in an effort to save a disappointing illustration. It gives you a chance to make a lot of corrections the easy way!

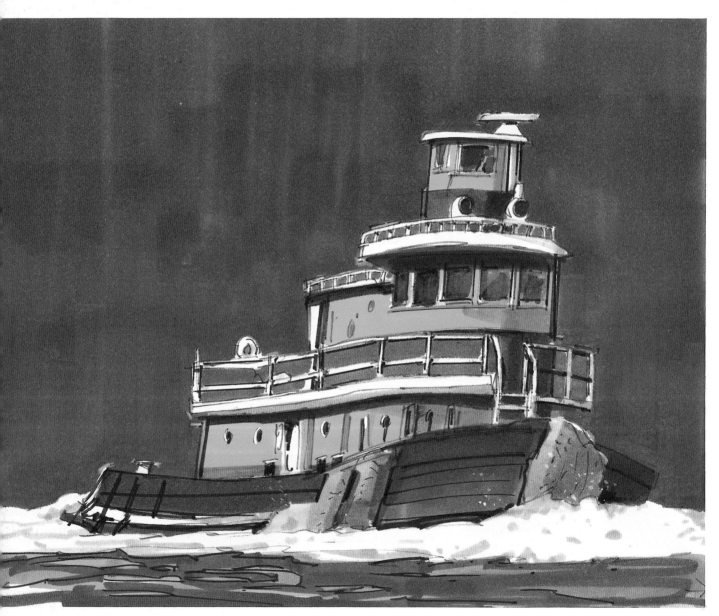

In this illustration I used a lot of moonlight color, but using even a very small amount is effective. Suggest a little moonlight by using a cream or maize marker. Or you can overlay an entire area with a dark color for depth, and then come back in with a light colored pencil.

I added cadmium orange in this illustration to contrast with the blue night color.
Cadmium orange suggests moonlight, usually coming from a high origin.

Prussian blue

Blue sky and stars.
It always works.

Space blue

Rodeo simply drawn, its light
added with a yellow pencil.

Indigo

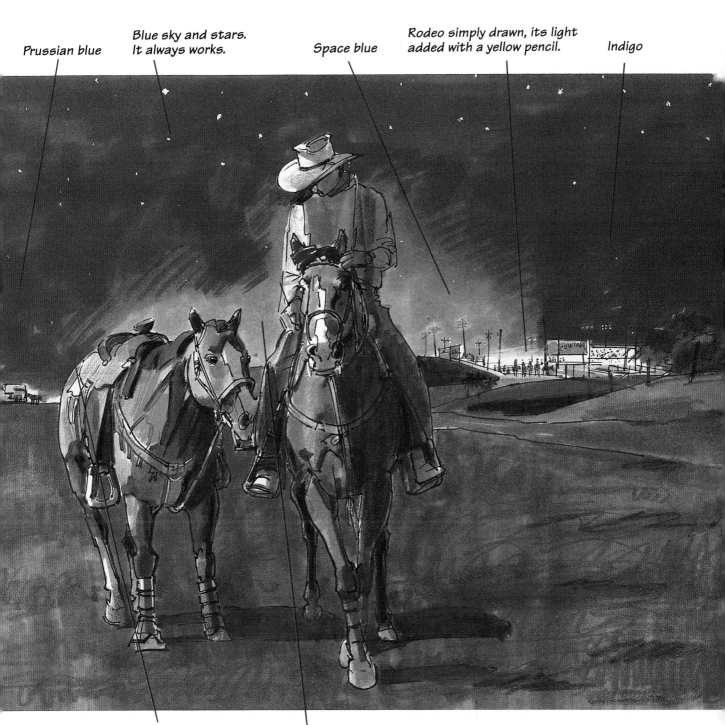

The sky can be very
dark against lighter
subjects.

Or make the sky very
light against dark
subjects.

REFLECTIONS

Shadows are great, but reflections are bigger than life. They call attention to the subject and give the illustrator an opportunity to take great liberties.

With a glass surface there are several options, but basically the reflection is a duplication of the subject in reverse. Remember, you are in control of the rules. The reflected image can be exactly the same as the object if you want, or it can be slightly darker, or it can be brought all the way to black. It's your call.

This is a pretty straightforward interpretation. The reflected image is slightly darker and softer than the original. It will always start at the same line as the original image. To keep the reflected image from being redundant, I often make it airy, choosing my light areas to flatter, and not compete with, the original image.

Keep the original linear and the reflection soft. Lay in the reflection, and scrub it with a cool gray no. 1 or pale indigo to both darken and soften it.

This is a typical wet surface reflection. I rarely make an exact duplication,
but rather suggest the reverse image and break it up with ripples and light
streaks. In this case, painted traffic lines serve the same purpose.

BUILDINGS

Most architectural drawings are detailed and involved— and beautifully rendered. The comp artist, on the other hand, does almost a caricature of this style: simplistic, but using some of the same tricks. Remember, buildings are only boxes with light, shadow, and windows.

Begin with a simple line drawing. Do the least indication possible to suggest facade detail. Apply large areas of color. Use the broad edge of the nib, and become accustomed to using the heel of the nib to go right up to the line.

Work briskly and boldly into the shadow areas. Leave some strokes unblended. Eliminate all whites, except highlights or accent areas, by using your markers to create a light tone.

To add figures, begin by washing an entire area with space blue. At the last minute, add color details as time permits.

Separate foreground, middle ground, and background by using different values. Use colored pencil for a touch of texture.

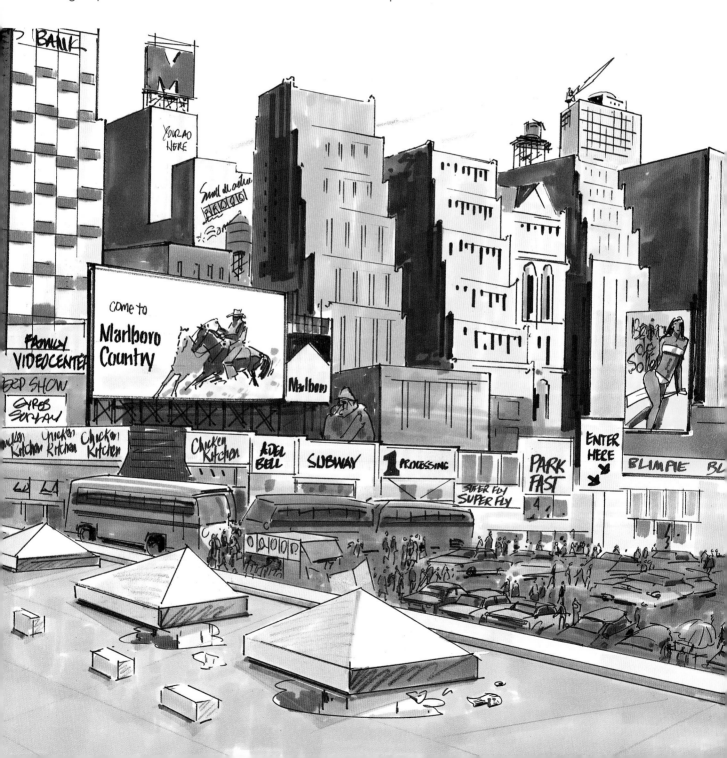

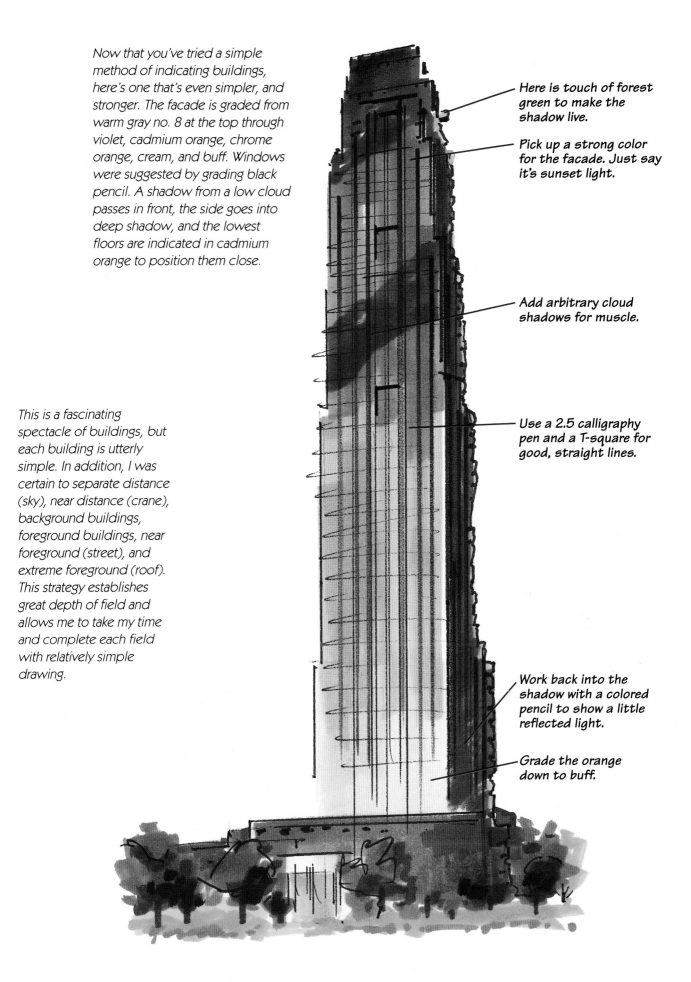

Now that you've tried a simple method of indicating buildings, here's one that's even simpler, and stronger. The facade is graded from warm gray no. 8 at the top through violet, cadmium orange, chrome orange, cream, and buff. Windows were suggested by grading black pencil. A shadow from a low cloud passes in front, the side goes into deep shadow, and the lowest floors are indicated in cadmium orange to position them close.

This is a fascinating spectacle of buildings, but each building is utterly simple. In addition, I was certain to separate distance (sky), near distance (crane), background buildings, foreground buildings, near foreground (street), and extreme foreground (roof). This strategy establishes great depth of field and allows me to take my time and complete each field with relatively simple drawing.

Here is touch of forest green to make the shadow live.

Pick up a strong color for the facade. Just say it's sunset light.

Add arbitrary cloud shadows for muscle.

Use a 2.5 calligraphy pen and a T-square for good, straight lines.

Work back into the shadow with a colored pencil to show a little reflected light.

Grade the orange down to buff.

STREETS

Like anything else, a street or road can be colorful depending on light, weather, and the type of surface. It can be indicated light or dark, simple or complicated. Manhole covers, grates, patches, cracks, stains, and painted traffic symbols all offer opportunities to embellish. Make your streets totally exciting and imaginative.

A wet road surface always offers more opportunity to add interest to the picture. Reflections of cars and nearby objects can add richness. White clouds appear reflected as streaks of white, complemented by dark accents from patches or other sources.

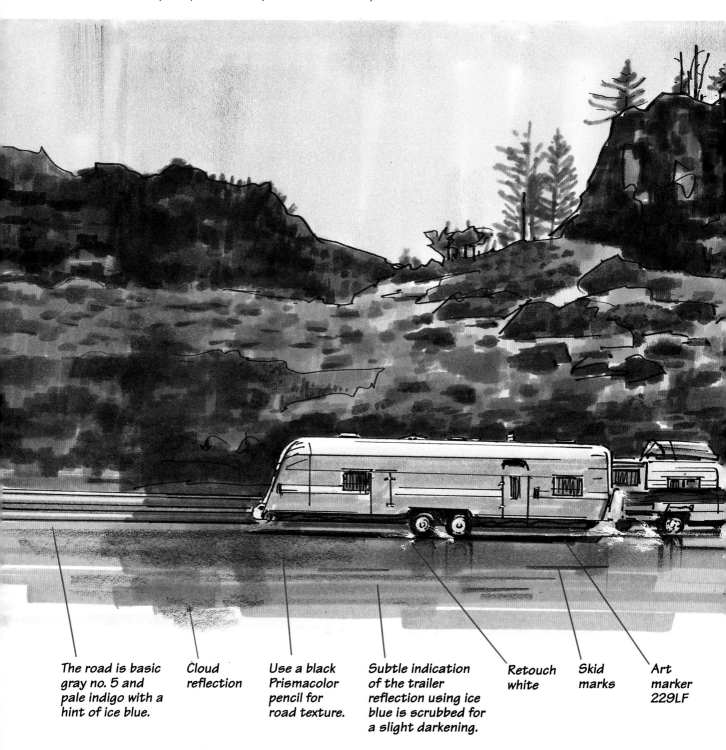

The road is basic gray no. 5 and pale indigo with a hint of ice blue.

Cloud reflection

Use a black Prismacolor pencil for road texture.

Subtle indication of the trailer reflection using ice blue is scrubbed for a slight darkening.

Retouch white

Skid marks

Art marker 229LF

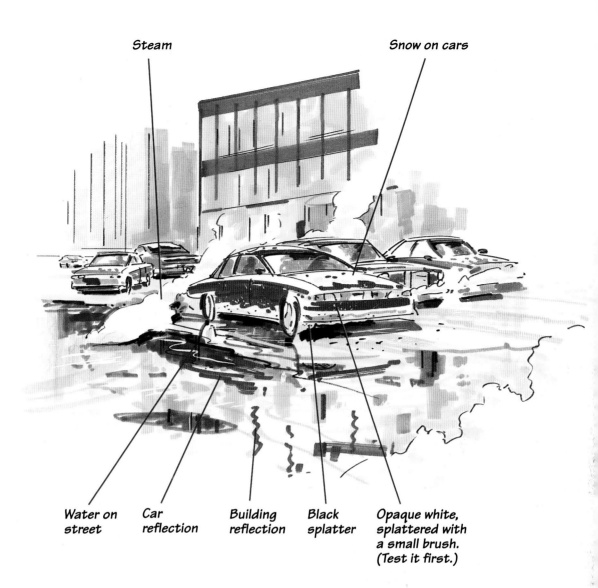

Steam

Snow on cars

Water on street

Car reflection

Building reflection

Black splatter

Opaque white, splattered with a small brush. (Test it first.)

Splatter white with a no. 2 brush. (Test it first.)

The road is usually lighter at the sides, where it has picked up fewer stains from oil and tires.

EXERCISE:

In this illustration, inspired by the work of car illustrator John Centani, I got as wet and splashy as possible. Try a similar scene yourself. Draw in the puddles, and then paint reflections as shown.

ANIMALS

The pet food industry spends heavily on consumer advertising—food for dogs, cats, horses, and pets of all kinds. Numerous farm trade publications need illustrations to advertise food supplements, medicines, and general feed. Someone has to draw all those animals, and it might as well be you!

All animals have a physical bone structure not unlike our own, but each animal is unique. It's important to know the animal's anatomy and how it moves, at least enough to do your illustration. Do a little research before beginning your drawing. The library and the zoo are good sources.

This team of draft animals was in a contest I had photographed recently, but the Chubb Collection of Equine Skeletons at the Museum of Natural History in New York City was an additional resource for this illustration. The group of skeletons there includes a draft horse in the act of pulling a heavy load.

Mane and tail: cream

Working on Plaza 90D paper (above) did not quite satisfy me for this assignment, so I switched to Denril vellum and varied the positions and color. As you can see, the effect is quite different. Either way, select as few colors as possible, and keep it simple.

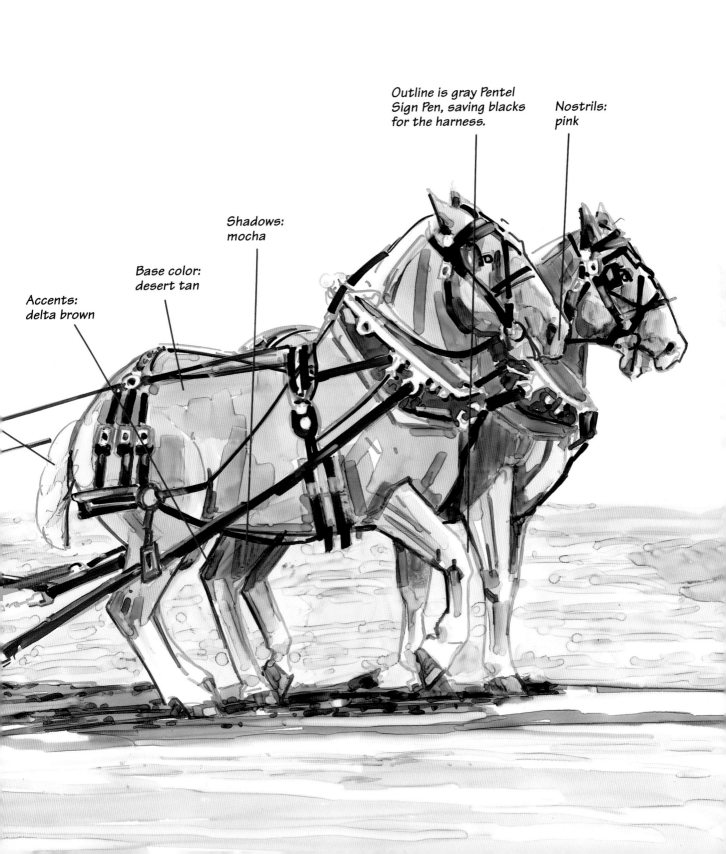

Outline is gray Pentel
Sign Pen, saving blacks
for the harness.

Nostrils:
pink

Shadows:
mocha

Base color:
desert tan

Accents:
delta brown

Fur

Fur can be treated in a simple, monochromatic style using values of a single hue, or it can be multicolored using reflected hues as well. Lighter base colors will always enhance drier, darker ones applied over them. This is a good opportunity to use your dry markers to good advantage.

I blocked in the white cat using pale indigo, warm grays, and line. Colored pencil was used to suggest the fine texture of the fur.

For the other cat, I used a wide range of colors: delta brown, redwood, goldenrod, suntan, beige, buff, desert tan, mauve, and purple sage. Deep salmon was used in the ears and nose. Of course this flamboyant use of color could be greatly simplified, but with a colorful subject like this, I enjoy overdoing it. If I think the result is too overt, it's a simple matter to overlay with a darker color.

Here are two examples of dogs painted in the same way. In the Irish setter, I used several colors of darker brown, dry markers over an undercoat of pale cherry to suggest both the texture and the color of the fur. I also used blues and mauves for shadowing the whites and for painting the light side of the nose and head.

The overall dark brown hair color of the second dog is enhanced by burnt sienna, purple sage, sky blue, violet, and black, as well as burnt umber.

SKETCHING

Using markers to sketch, inside or out, is simple and clean. If you're traveling, a few of your favorite markers will be enough. Work quickly enough to get the adrenaline flowing, Later, in your studio, you can spend more time to complete the sketch if you choose.

I carry a set of 48 Berol Prismacolor sticks—like colored pencils in a larger stick form—to complement my markers. Try combining the two mediums and leave whites only as accents.

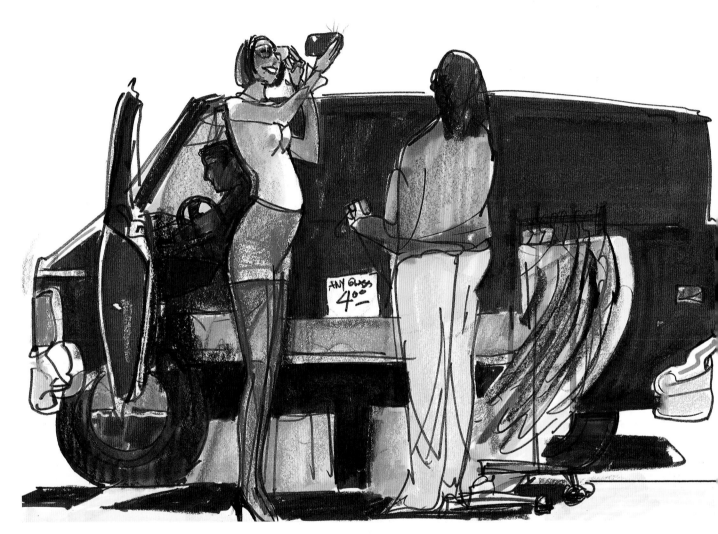

The texture of the car was created by going over Prismacolor red color bars with a life red marker. Dutch blue marker was then used over both.

It's a good idea to use marker both by itself and in combination with Prismacolor bars. Also use a Design Art Marker 229LF freely. It will not bleed on the very porous sketchpad stock, but will soak in quickly and become very textural.

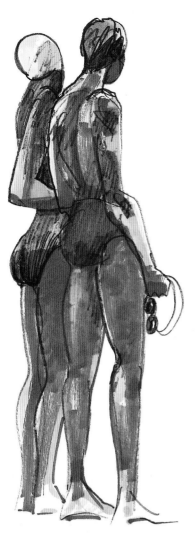

Sketches done at the
Manhattan Plaza Swimming
Pool, using a black Pentel
Sign Pen and a Design Art
Marker 229LF to tone figures.

What's more pleasant than listening to Bach and
sketching? This sketch of a cathedral concert was done
with a limited palette of cool gray no. 5, pale sepia,
mauve, burnt sienna, and pale yellow. Later I added
process blue and Pantone green M.

Simply tuck your sketchbook under your arm, put a
few markers in your pocket, and you're set to go
anywhere. No easel, no paint box, and no water!

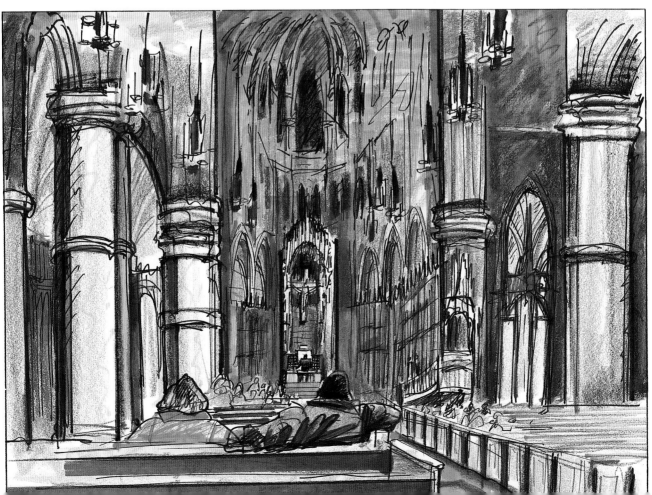

INVISIBLE PATCHING

There will be many times when you or your client will want to make changes in an illustration. Often you can save a good sketch and a lot of time by replacing the offending part—a face, a large area, or a color. Many mistakes with marker are difficult or impossible to correct by reworking the original drawing, so feel free to patch with impunity.

There are two ways to do this. First, carefully trace the outline of the portion to be redone. Then after repainting, cement the replacement over the original. You'll usually have to back it up with a light bond paper before cutting it out, to be sure that it's opaque. This procedure may leave a white edge, which you can eliminate by coloring the edge with marker. Then bevel the edge of the patch with your fingernail to make it less conspicuous.

The second method is to trace the section and redo it, and then after being certain it's in perfect register with the original, cut out both pieces with an X-Acto knife. You now have a painting with a hole and a revised plug to fill the hole. Set the new plug carefully into place, and use Scotch 811 Removable Magic Tape in the face of the painting to prevent the plug from slipping. This special kind of tape will not damage your illustration when you remove it.

Now turn over the illustration and tape it on the back. Use the same Scotch 811 tape in case you have to make another change later. Then remove the holding tape on the face of the illustration. Use your fingernail to burnish the two edges together. Run your finger over the patch to see whether you can feel the edge. When you can't, it will be totally invisible.

Original face cut out simultaneously with replacement face

Replacement face taped on back with 811 Scotch Removable Magic Tape

Edge burnished with fingernail

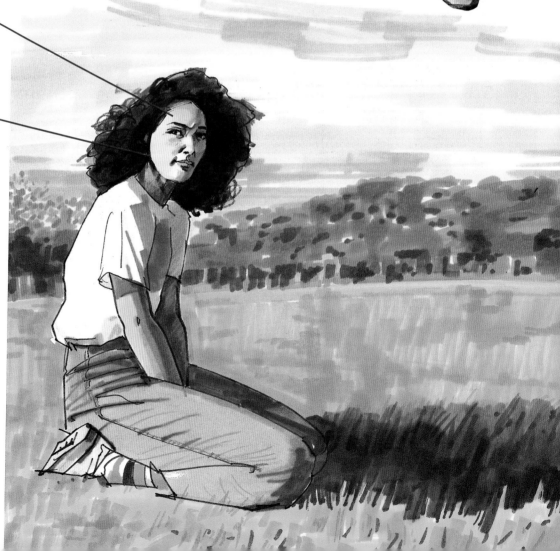

INCREASING SPEED

Now that you're familiar with basic marker techniques, try to increase your speed. Set a timer or give yourself a tight deadline, pacing yourself so that you finish every element in the illustration within the allotted time. If you finish early, go back and check everything, patching in or correcting where it's needed most.

Get into a good habit right away: Always finish your assignments on time. Often you will have enough time left so that you can go back and check the drawing, values, and color—as well as review all of the specs for the job.

Draw from memory often. Sooner or later you'll be called on to draw quickly and with no scrap. This is another way to pick up your speed. Give yourself a situation to draw and a time limit. Now go to it, and good luck!

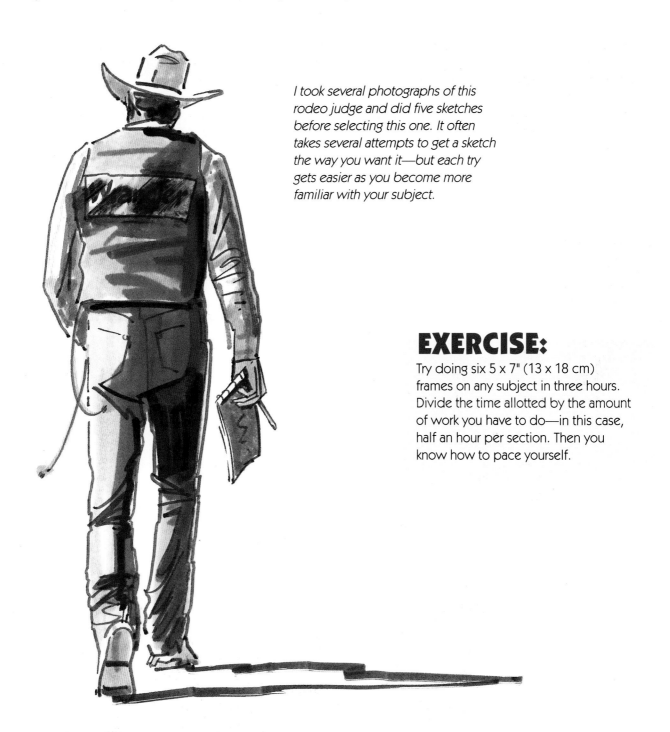

I took several photographs of this rodeo judge and did five sketches before selecting this one. It often takes several attempts to get a sketch the way you want it—but each try gets easier as you become more familiar with your subject.

EXERCISE:

Try doing six 5 x 7" (13 x 18 cm) frames on any subject in three hours. Divide the time allotted by the amount of work you have to do—in this case, half an hour per section. Then you know how to pace yourself.

INDEX